Drawing
WORKSHOP

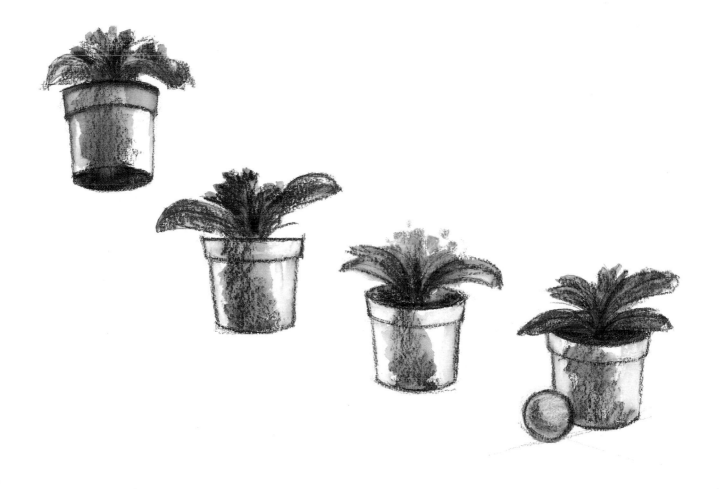

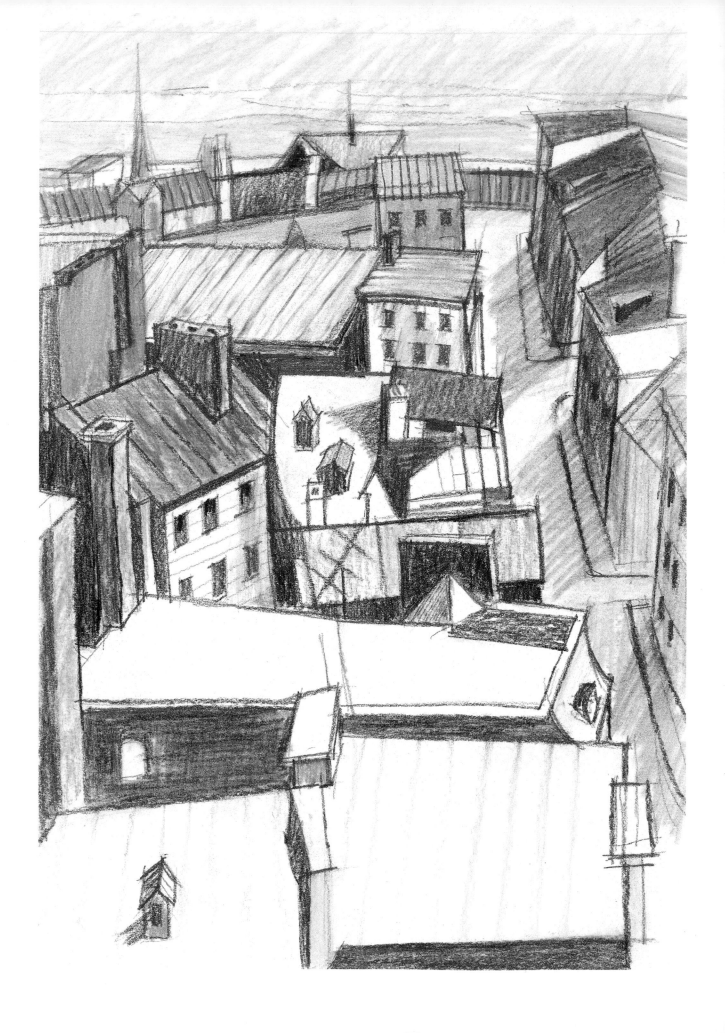

DOREEN ROBERTS

HarperCollins*Publishers*

'Double double, toil and trouble;
Fire burn and cauldron bubble.'

Macbeth

My thanks to Cathy Gosling, senior
commissioning editor, Daphne Tagg, editor,
and Caroline Hill, art editor, who stirred up
the cauldron of my words and pictures and
produced from them a verbal and visual meal
we all hope will be enjoyed by many.

For Kathleen

First published in 1991 by
HarperCollins Publishers
London

Reprinted 1992

© Doreen Roberts, 1991

**A CIP catalogue record for this book is available
from the British Library**

ISBN 0 00 412550 9

Editor: Daphne Tagg
Art editor: Caroline Hill

Typeset by SX Composing Ltd
Printed and bound in Hong Kong

contents

introduction

If you are one of those people who say, regretfully, 'I can't draw, I can't even draw a straight line', don't worry. If you can write, you can learn to draw and make marks to create a visual language.

People often ask me if they have to be able to draw before they can paint. Of course there are exceptions to everything, but if you want to do good work the answer is, emphatically, yes. This question implies that painting and drawing are two quite separate things, one depending on a brush and the other on a pencil, and that people don't want to waste time on something that they think will keep them from painting pictures straight away.

The two activities are interchangeable. You can draw with a brush and 'paint' with a pencil. With the production of more and varied drawing tools and media, the line between drawing and painting becomes even less clear. When does a pastel drawing become a pastel painting? Is a work made with a water-soluble graphite pencil a monochrome drawing or a painting?

As you work through this book you will find that drawing, with whatever tools you choose, is the basis of all painting, even if lines are not seen. Good drawing is the evidence of the understanding of structure, and that understanding, or lack of it, will show in your paintings. Michelangelo could never have painted the ceiling of the Sistine chapel if, by drawing, he hadn't understood the structure of the human form.

Charles Keeping, illustration from 'Adam and Paradise Island'. A fine example of the use of line, tone and subtle colour.

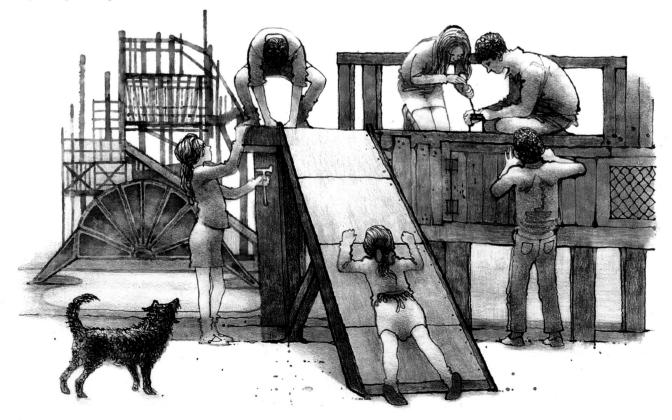

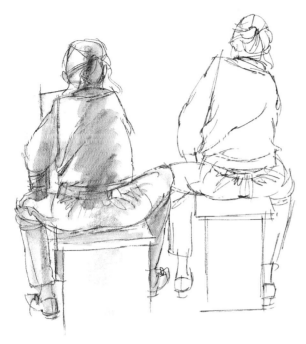

Watercolour pencil, tone drawing (left); *pen*, line drawing (right).

Drawing is also a means of communication, and a universal language. Before the invention of photography, travellers to distant places used words to describe what they had seen, and this sometimes resulted in a distorted idea, since words alone are often inadequate if there is no common experience. However, if the travellers could draw well, they could easily be understood by others.

We are conditioned by words and our efforts are conditioned by other people's expectations, particularly when they assume that what they see and how they see it is the only valid way. For example, if we attempt to draw a flower, it is judged by the ignorant according to the way they see a flower and whether they think the subject of our work is 'beautiful' and therefore worth any effort in the first place.

You do not need to show anyone anything, nor should you worry about achieving a 'frameable' result until you're ready. You don't even have to know special techniques before you start drawing. What is the point of learning, for example, how to 'cross-hatch' if this technique is never appropriate to the sort of drawings you do?

What is absolutely essential is that you learn to control all your drawing tools so well that you can make them do anything you want. Make up your own mind, work at your own pace, think your own thoughts and learn to do your own work your own way, but don't be too proud to learn.

To learn well, whether we are amateurs or professionals, we need a sort of passion – the ability to have a love affair with our subject, to develop a spirit of enquiry and adventure and to devote time and effort to our love.

The ability to draw starts with *looking* and *perceiving* and learning *how* to look and perceive. It is this that drives the hand which holds the drawing tools, which make the sort of marks which will become a visual statement about things seen or felt.

Most people, seeing a landscape or a cup, will think of these things in terms of words, and of their place in our lives. Artists will be more aware of shapes, patterns, light, colour and so on, and they will see everything more clearly, unhindered by conventional 'labelling'.

I can almost hear some of you saying, 'But all this still doesn't help me to draw. I still can't use a pencil, shade, draw a shape.' But it will, you'll see. Attitude has a lot to do with learning.

Of course, to a lot of people, the word 'work' is an unpleasant one, as it may represent years of being employed by others doing something which is neither of interest nor satisfying. I know the feeling, but work is marvellous if it is for your own interest.

You can learn to develop the imagination. You can learn how to use tools and materials. You can learn how to look. What you can't learn is the willingness to give your heart to your work and to develop yourself through it. That comes from you and not your teachers.

And to the statement I often hear among students, 'But I'm getting on, I haven't time', I'd ask, 'Time for what? No time to spend learning something you would like to do well? No time to make steady progress? No time to enjoy yourself?'

So take your courage in your hands and make a start. Drawing tools should be an extension of your hand and not an end in themselves. Although they have their own tactile qualities and their own vitality, you make the marks, not the equipment, and there are many ways of seeing and many ways of interpreting what is seen. The drawings and photographs in this book are not meant to be copied but are there to point the way to your better understanding and enjoyment.

There will be projects at the end of each chapter to help you with extra practice. Try to invent others for yourself and try to do some drawing every day. Be kind to yourself and just start at the beginning.

You *can* learn to draw.

1 drawing tools and preparation

If you are going to take your drawing studies seriously, you should collect together a good range of basic tools both in black and white and in colour. Although coloured pencils, pastels and chalks come in pretty boxes, it is better to buy a few separately to start with and add to them gradually than to pay for colours you never use.

Most of the drawing tools mentioned in the text are shown in the illustrations so that unfamiliar ones can be identified.

A good way of storing all your tools is to buy a long plastic food box with a lid. Pencils can be strapped with an elastic band to strips of card to stop them rattling about.

BLACK AND WHITE

Pencils (graphite)

These are the most common drawing tools and are marked according to their hardness. H, 2H through to 6H or higher is the hard range and B through to 9B is the softer range. This is more suitable for general drawing. For a start I suggest you get a 2B, 4B and 6B and add to these later if you want.

Graphite pencils are the only ones which have such a wide range of grades. Other drawing tools usually come in three grades: soft, medium and hard.

Graphite sticks

These are thick sticks of 'lead' (usually hexagonal) without a casing. It's a good idea to wind masking tape around them to keep fingers clean; the tape can be unwound as the stick gets worn down. A soft grade is the most useful.

Pastel and chalk

Black and white chalks and pastels of all types and hardnesses come in sticks or encased in wood. There are many names for this medium – Conté pencils, pastel pencils, carbon pencils – and there are several makes. Buy the softest grades of each type as these are usually smoother to work with. If there is a choice of round or square sticks, the latter are more useful, as the corners, the edges and the flat sides can all be used to produce different marks.

Charcoal

Compressed charcoal sticks are usually round and are a marvellously rich medium, although messy (always keep a damp tissue near).

Willow charcoal is sold in boxes of sticks. I find that it is a very 'grey' medium and it is difficult to achieve rich darks, but it should be tried.

Pen and ink and water-soluble tools

Mapping pens. The type illustrated here allows the nib to be reversed into the holder to protect it.

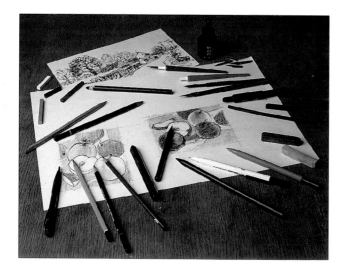

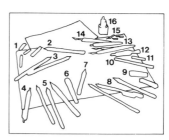

1 Conté sticks	**10** Willow charcoal
2 Conté pencil	**11** Compressed charcoal
3 Water-soluble graphite pencils	**12** Compressed charcoal in holder
4 Graphite lead clutch pencil	**13** Two dip pens
5 2B, 4B, 6B graphite pencils	**14** Mapping pens with reversible nibs
6 Graphite sticks	**15** Dip pen nibs
7 Graphite sticks covered with plastic	**16** Indian ink
8 Assorted pens	
9 Pastel sticks	

Dip nibs and holders. A Gillott 303 nib is a useful one to get.

Black indian ink. This is waterproof but can be diluted with water for use as a wash.

Water-soluble graphite pencils. These come in three grades – medium, soft and very soft – which vary according to the manufacturer. I suggest you get one of each.

Pens. A random collection of black or blue-black ball points, fountain pens, roller-balls, felt-tips and so on – you probably have a number of these in the house already.

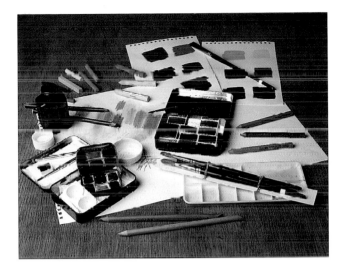

COLOUR – DRY AND WET

Pencils and pastels

To learn to use the full range of mark-making tools, add some colours to your black pastels and pastel pencils. Buy darker colours to start with, say a rich brown (Vandyke Brown), a dark grey (Payne's) and a dark blue (Indigo). If these colours are not offered in the brand available, then ask your shop for the closest equivalent.

Get at least these three dark colours in good quality 'dry' coloured pencils and in water-soluble ones – soft ones if you have a choice.

Water-soluble crayons make broader marks than pencils and so are good for larger areas of wash.

A few oil pastels are useful. They resist water, so little puddles settle within oil pastel lines and they also create interesting broken lines.

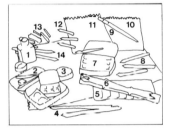

1 Water bottle and lid	**8** Water-soluble crayons
2 Travelling watercolour kit	**9** Flat-ferruled brush
3 Water container	**10** The six basic colours
4 Coloured pencils	**11** Additional colours
5 Mixing palette	**12** Oil pastels
6 Brushes on card	**13** Round and square pastels
7 Tin of watercolours	**14** Pastel pencils

Watercolours

Artists' quality watercolours are the best, but for wash drawings almost any quality can be used, although buying cheap ones can be a false economy.

It is also quite unnecessary to buy a fitted watercolour box. Many professionals don't own special boxes. A good way to start is to buy a small tin and fix a few whole or half-pans of Artists' quality watercolours to the inside using double-sided sticky tape.

The two boxes illustrated are quite small. A folding (or 'travelling') brush and plastic palette (or a plain tea plate) would complete the set. The small box contains Cadmium Red, Burnt Umber, Ultramarine, Payne's Grey, Burnt Sienna and Neutral. The whole pan could be exchanged for a half pan to leave room for a deep green.

If you wish to buy a complete range of basic colours I would advise you to get a 'cool' and 'hot' version of each of the three primaries, i.e. Lemon Yellow, Chrome Yellow; Vermilion, Crimson; Ultramarine and Prussian Blue. Raw Sienna, Burnt Sienna and Indigo are useful extras.

Always buy materials and tools from a good art shop catering for professionals as well as amateurs, which will have assistants who are likely to know what they are doing. All the same, you should always try to know, in advance, exactly what you want.

I have known a beginner go to her local shop and ask for 'paper for gouache' and 'a plastic eraser'. She was sold a sheet of very thin watercolour paper (which would have been suitable if the paint were used opaquely but would have needed stretching otherwise) and a putty rubber quite unsuitable for the work in hand. In the case of the eraser, the student had asked for the right thing, and had questioned why she was given something different, but had then accepted the assistant's reply that they were the same.

PAPER

A word about paper sizes will help you understand any recommendations in this book.

There is an 'international' series of paper sizes pre-fixed by 'A', each size being a half of the next. A1 is the largest and A5 is the smallest we are likely to need. Some countries still use 'imperial' measurements, and in my research for this book I found all sorts of random sizes as well.

The two main systems compare like this:

A sizes	Imperial sizes
A1 840×594 mm (33×23⅜ in)	Imperial 30×20 in
A2 594×420 mm (23⅜×16½ in)	Half imperial 15×20 in
A3 420×297 mm (16½×11¾ in)	Quarter imperial 15×10 in
A4 297×210 mm (11¾×8¼ in)	

A good size to start with is A3 or quarter imperial. This is big enough to give freedom and compact enough to use if you have no special workroom or studio. Try to avoid buying pads of paper. Buying A1 sheets and cutting them in two or four is less expensive and means you can buy sheets of different types instead of being stuck with one. There is a proviso about this. Paper should always lie flat and un-creased – it should look untouched and tempting. So if you buy sheets, fold them very carefully, slice them gently with a large, sharp knife, and store them in a folder. This could be bought or made out of two sheets of mounting board or card cut to about 4 cm (1½ in) larger all round than your paper, with a cloth hinge stuck on with PVA glue.

If you do buy pads, never work with the paper still curved over if they are glue-bound. Take the sheet out of the pad so that it lies flat. Spiral-bound pads are fine for working outside the house, and so are sewn books, as these can be opened out to give a double spread when needed.

Get a generous supply of good cartridge paper. There are many papers on the market but this will do for most work. If your shop sells it, try a sheet of dead white, very smooth paper as well, as this is suitable for pen drawings.

If you fancy a tinted paper for pastel and chalk work, buy a pad of Ingres paper, which contains a selection of different colours. Other papers can be added as you progress and investigate more areas. I found that in these 'fancy' papers, the pad sizes varied tremendously, especially when they were imported from different countries.

Buy tracing paper in flat sheets rather than in a roll as the curl is difficult to work with and takes a long time to flatten out in a folder, if at all.

tip

Every time you buy a different type of paper, cut off a strip and write on it the make, name, size, surface, weight and any other particulars, so that you have an information swatch for the future.

BRUSHES

If you are not sure if you are interested in drawing with wash and colour, just buy a synthetic no. 6 or 7 round-ferruled brush (rather than a flat one), or stick to the small folding brush in your tin of watercolours.

Top quality, pure sable brushes are a good investment but are made by hand and are therefore very expensive. If you want to buy one, a no. 8 is a good size, as it can be used for broad and fine work if it has a good point. Don't go smaller than no. 6. Apart from pure sable, there are sable mixtures, ox, squirrel and so on. Hog hair brushes are not appropriate for watercolour or for any work you are likely to do based on the projects in this book.

Here is how to choose a good round brush made of natural hair:

Brushes are graded in series which are named or numbered and indicate a range of quality and prices. Find the series most likely to suit you and your pocket (ask the assistant or read the cards which most shops have) and choose a brush which looks as if it might have a good point. If there is no pot of water nearby, ask for one. If the assistants laugh or look astounded, leave the shop. All good art shops will have a pot there, will refill it if dry, or will supply one without question.

Take your brush and swill it in the water so that all traces of point-making gum are removed. Shake the water out, hard, on the floor. (Watch out for other customers and shelves with paper!) Then flick the point briskly across your finger-nail. The brush should spring back into its point. If it doesn't after several goes at rinsing, shaking and flicking, try another brush and keep going till you find one that makes a point.

Don't be intimidated: *you* are spending the money, and a good sable can last for many years. A brush with a split point or no spring is useless.

As an extra, a synthetic, square-ended medium-long-haired brush is useful for blunt-edged strokes; 1 cm or 1.25 cm (3/8 in or ½ in) widths are suitable.

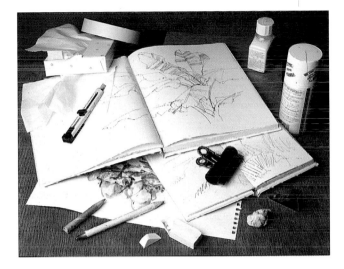

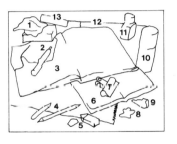

1 Box of tissues
2 Knife with snap-off blades
3 Notebook
4 Stumps
5 Eraser slivers
6 Small notebook
7 Bulldog clip
8 Putty rubber
9 Drawing board clip
10 Fixative
11 Masking fluid
12 Notebook
13 Drafting tape

OTHER USEFUL TOOLS

A putty eraser. This is slightly sticky and is little use for erasing, but moulded and pulled into peaks it will 'lift' soft marks.

A plastic eraser. General purpose.

A tortillon or 'stump'. A tightly rolled, pencil-shaped paper tool useful for smudging or blending marks. (Cotton buds work nearly as well.)

A sharp knife with snap-off blades.

A can of ozone-friendly fixative.

Four large bulldog clips or drawing-board clips to hold the paper to your board.

As an alternative to clips, try drafting tape, *not* masking tape. Drafting tape has a lower tack and is less likely to tear your paper.

Two notebooks, one pocket size and one A4 or a bit shorter. These should have good, sturdy, all-purpose cartridge paper.

A flat box of tissues.

A drawing board. You can buy what you need from a hardware shop rather than an art shop. Plywood

(approximately 9 mm or 9-ply thick) is sturdy enough not to warp if it is made wet and is light enough to carry without stress. Get a piece cut which is about 3 cm (1¼ in) bigger all round than your A3 paper. (If you have a wider border your clips won't reach the paper.) When you come to use A2 paper, another piece of board will not be a great extra expense.

The quality of plywood varies. I buy beech ply, which is a little bit more expensive than 'blended'.

Stretching paper

If paint is used wetly – for instance in pen-and-wash drawings – it can cause paper to cockle, which makes it difficult to control the paint. Stretching the paper minimizes this and is worth the effort.

Make sure that your board is free of grease – a quick gentle rub with fine sandpaper before you first use it will make it more receptive to damp paper and tape. You also need a clean tea-towel or cloth and some gummed tape – the sort that has to be wetted to make it stick. Cut strips of tape about 4–5 cm (1½–2 in) longer at each end than the length and width of your paper. Get everything ready and the board laid flat near the sink, bath or basin before you start.

Now either immerse your paper in the water or pass both sides under a running tap. Hold it from one corner for just a few seconds to let the water drain, then place it on the board. Lay your cloth on top to take up some of the water, quickly run each gummed strip under the running tap and tape down each side. Blot gently (don't rub) with the cloth and leave to dry flat. Any cockling will flatten out if you leave it alone.

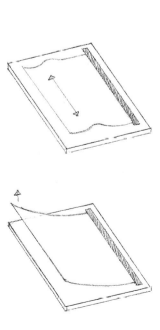

tip

If you are slow in getting the tape down and the paper begins to cockle too soon, look at the direction of the cockle. If it runs the length of the paper, as shown here, gently lift one of the long sides and pat, also gently, from the opposite side as you re-lay it. Don't rub it down or you will rough up the good surface of the paper. If the cockle runs across the paper, lift one of the short sides and pat down from the other. Gently does it. Practise with some old drawings.

GOOD WORKING POSTURE

How many of us really consider how we sit when working and how we hold and handle our tools? To understand this for yourself, try these experiments.

Sit on your normal working chair at your normal table, with your drawing board and paper (any paper will do) lying flat on it or very slightly propped up on some books. Now draw – anything – or just scribble, with a pencil, and notice what is happening.

Most of you will be holding your pencil as if it were a pen, you will be bent over your work, with your eyes fairly close to the paper and your chin pushed forward. This means a number of things. You will have free movement of your hand only from your wrist, which will be resting on the paper; you will only see your work from close quarters; you may have your chin raised and will be contracting the muscles at the back of the neck, and therefore jamming the vertebrae together. If you wear bifocal spectacles it will be even worse!

This situation is tailor-made for artistic and physical disaster, since you do not move away from your work in order to assess it (how many of us can be bothered to push back a chair, get up and move away every ten minutes or so?) and your neck spine may need therapy – especially if you are no longer young and flexible.

Try a second experiment. Sit at the table on the same chair, but put your board and paper on your lap and resting against the table. Now draw or scribble.

You will find that you have freedom of movement from your wrist and elbow (although your wrist will be at an uncomfortable angle), your back will be straighter, you will see your work from farther away, and you can tuck your chin in slightly to keep your neck spine from contracting.

Now try a third way if you have an easel. Stand up to work. You will see your work easily, can move away easily, will have freedom from the wrist, elbow and shoulder, and no stress on the spine, unless you are very tense. If you are, try consciously to relax. Focus your attention on all the parts of the body which get tense and deliberately let them relax – brows, eyes, mouth, neck, shoulders and so on.

Standing to work is better physically and from the point of view of looking at what you have achieved if you are working on a fairly large scale, but it isn't easy to stand for a long time. Put a chair at least six feet away so that you can rest your feet and consider your work at frequent intervals.

When sitting at the table with the board on your lap, you will not have found it easy to make fluid marks on the paper, so there must be another way of holding your tool.

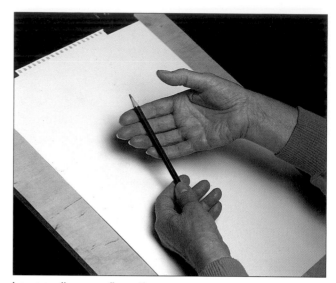
Lay pencil across fingertips.

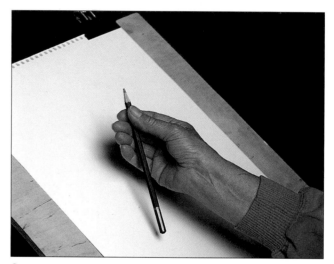
Grasp pencil between forefinger and thumb.

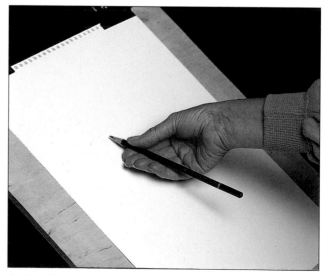
Angle of board too shallow.

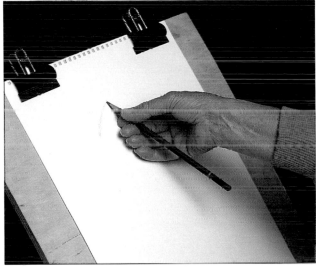

Board and hand adjusted comfortably.

The photographs here show clearly how it can be done. Hold your drawing tool across your fingers, between them and your thumb. Tilt your hand and – fine! But is it? If your board is too near the horizontal, your tool will not reach. When you get the angle of your tool and board right, you will be able to rest the backs of your fingers on your paper so that your hand has support and total freedom for lovely big movements and can change quickly to a closer hold for any details.

In the illustrations on this page you will see some of the marks made by different tools. Try out every drawing tool you have on A3 sheets to see just how much can be done with them and how far you can stretch their natural potential. Put the date and the name of the tools and media on the back of each sheet and keep them in your portfolio.

Before we go on, perhaps I should clarify my use of the term 'medium' (and its plural 'media') as distinct from 'tool'. In the case of pencils, the pencil is the *tool* – the means of using the material, or *medium*, which may be graphite or pastel. In ink drawings, the pen is the tool and the ink is the medium, and so on.

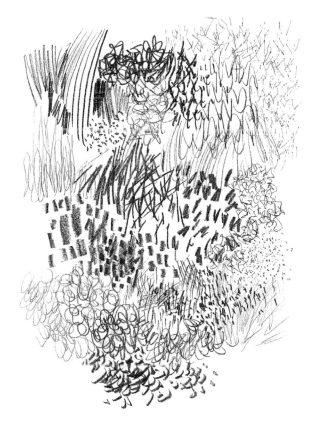

Experiments with a *4B pencil*.

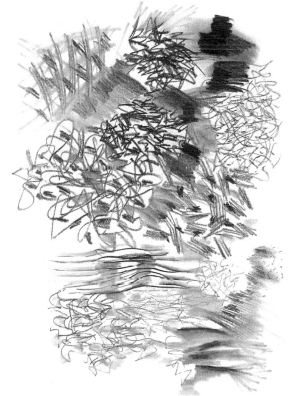

Experiments with a *pastel pencil*.

project

For your first project, try sheets and sheets of experiments with your drawing tools, making all sorts of marks and then combining them in as many ways as possible. Those of you who are good at permutations will realize just how many combinations there can be. Find out how you can use your tools.

2 beginning with line

How were your experiments? Did you make small, neat areas or did you simply use your tool 'mindlessly', allowing your hand to move around freely? This method is best for discovering how your tools can be used. But you must *watch* what you are doing, otherwise your first instinctive marks will be not just mindless but useless! Lots of people say, 'Oh, that's just a happy accident, I didn't plan it,' and they leave it at that. Think how useful it would be to make these happy accidents work for you at other times.

If your experiments have not been sufficiently in-depth, before you move on, re-do them until you know exactly what you can do with each tool.

Many amateurs want to be taught 'techniques' and often turn to books for this, but techniques result from the way you use your tools and what you want to show in your work. The best way is to find out for yourself. After all, we are all different and the techniques I or other artists use may not suit you.

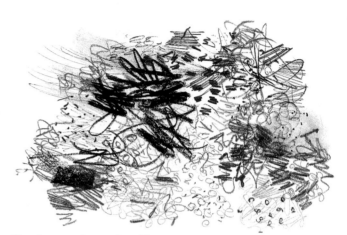

Random marks made with *oil pastel, graphite pencil and stick, pastel pencil, and pen.*

Raymond Spurrier, 'Gaios Paxos'. *Pencil.* The direct use of line gives a feeling of immediacy and vitality.

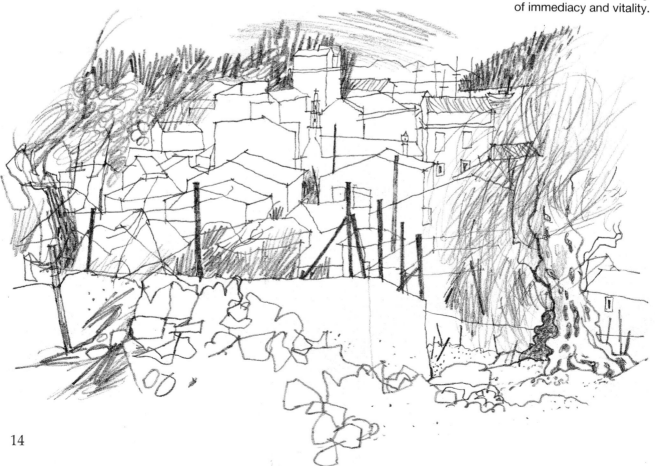

Writing this book has made me analyse my own way of working and I can think of no occasion when I decide on a technique for its own sake. I pick up tools and use them in a way which I think will express what I want to say.

The way our eyes see
Human beings have binocular vision, which means that we see in three dimensions. One of the problems in learning to draw is how to translate our three-dimensional world on to the flat, two-dimensional plane of our paper. If you copy other people's work or photographs (even if the latter are your own), the subject will already have been translated into two dimensions for you and you will bypass the problem. This may make life very easy, but it won't help you to learn well or to do anything fresh of your own.

For learning to draw there is no short cut, but the learning process can be exciting. Drawing is like detective work, a voyage of discovery, and you will succeed in the end if you make your tools follow an enquiring mind.

Those of you who drive a car will remember that as a beginner it was difficult to keep your mind off the wheel, the gear shift or the foot pedals and your eye from watching the front of the bonnet. Experienced drivers keep their eyes and minds on the road ahead and their attention on their peripheral vision. They don't need to think about the controls consciously at all.

It's the same with drawing. Keep your mind on what you want to show more than on how you are doing it and, with practice, your hands and tools will follow.

Pen lines used freely to suggest movement.

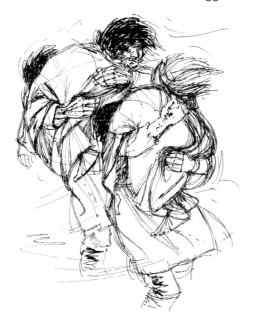

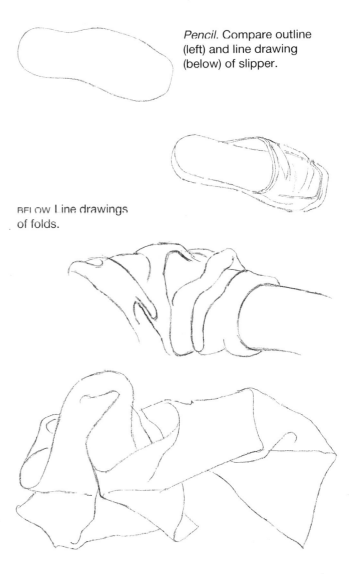

Pencil. Compare outline (left) and line drawing (below) of slipper.

BELOW Line drawings of folds.

LINE OR OUTLINE

There is a difference between *line*, which describes the form, and *outline*, or contour drawing, as you can see from these drawings of a slipper. Outline doesn't exist in the three-dimensional world; it represents the point at which part of our subject, whatever it is, disappears from sight because it turns away from us. For example, we represent the horizon with a line, but this is really where the globe curves away beyond our vision.

It is even more important to understand that the 'outline' is determined by whatever form the object has. Look at a sleeve which has folds; the outline will not be a continuous line but will be broken according to the way the folds are formed. Any outline drawn without reference to the 'inside' is likely to be inaccurate – if the folds are put in afterwards, they won't 'fit' the outline and the drawing will lack any real structure.

15

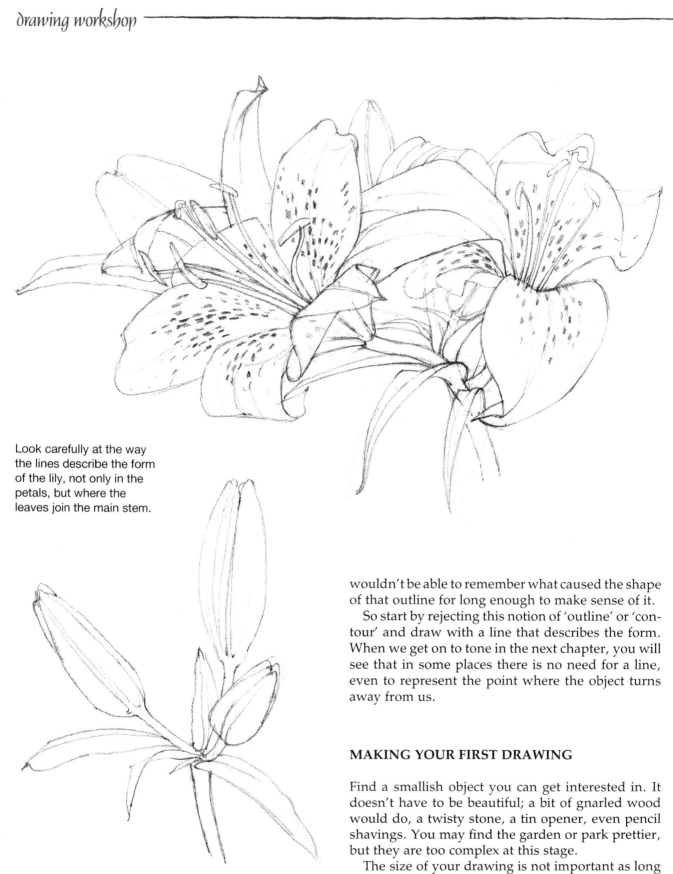

Look carefully at the way the lines describe the form of the lily, not only in the petals, but where the leaves join the main stem.

There is another factor to consider. The images received by our eyes are confused by our peripheral vision and interrupted by blinking. This means that if we were to record only the outside of forms, we wouldn't be able to remember what caused the shape of that outline for long enough to make sense of it.

So start by rejecting this notion of 'outline' or 'contour' and draw with a line that describes the form. When we get on to tone in the next chapter, you will see that in some places there is no need for a line, even to represent the point where the object turns away from us.

MAKING YOUR FIRST DRAWING

Find a smallish object you can get interested in. It doesn't have to be beautiful; a bit of gnarled wood would do, a twisty stone, a tin opener, even pencil shavings. You may find the garden or park prettier, but they are too complex at this stage.

The size of your drawing is not important as long as it is big enough to show the object comfortably. As a rough guide, a drawing of a purse, opened, should nearly fill an A4 sheet, especially if a thick tool like Conté or chalk is used. The bigger the tool, the bigger the drawing.

Look at the object as if you've never seen such a thing before, as if it were completely foreign to you or as if you have been blind. Then shut your eyes, feel it, follow its lines, turn it, describe it to yourself (visually but not verbally), and feel the texture, the folds, or whatever. Investigate it.

Now put it close beside your board so that you can see it without having to turn your head and you don't have to peer. Don't hold it, otherwise it will move every time you do. Make sure your paper is flat and fixed securely to your board and that the board is at the right angle.

Now look at your object carefully. Is it wider than it is long or vice versa? By how much? Twice or three times? Take a shoe, for instance. At what point does the upper start, compared with the whole? Where does the strap start and finish? Where do the laces fit? And so on. When you've really explored it by looking carefully, you are ready to start.

Beginning to draw
Find a central or key point and begin from there. It doesn't really matter where you begin as long as it's not round the outside!

Look hard and often. In fact you should look more than you draw, leaving your pencil still touching the paper each time you look up. As I have said, our eyes retain images for a very short while, so any time taken to replace your pencil will interrupt and negate your looking.

A piece of rock crystal shows shape and form clearly; it would be impossible to draw this accurately by starting with an outline and filling in internal divisions.

BELOW An overlay of the drawing, showing the order in which it developed.

Pencil. Lines showing connections and directions have been left in. These lines are put in as the position of one point is assessed against another; they are not guidelines which are put in first.

Moving outwards from your starting point, compare space, shape and distance from one point to another, backwards and forwards, as you draw. Each part of your object relates to another and is affected by it, so even though you can draw only one bit at a time, you should be constantly aware of what these relationships are.

When you reach the point where the object turns away from you, return to near your starting point and move in another direction, looking and comparing and exploring all the time. Try to understand what you are seeing and look for things like joins, thickness, follow-through (where the bottom of a box 'disappears' inside, for example).

If you make an inaccurate mark, don't erase it, just make the alteration and leave the old mark there for guidance – it will help you judge your alteration better. If you are drawing lightly it will cause no problem; drawings don't have to be tidy, and several loose, light lines are preferable to one rigid one.

If things get a bit snarled up, erase as much as is helpful and leave the rest in a state of 'maybe'. When I was at art college we weren't allowed to use an eraser when we were doing life drawing. It was tough, but it taught us to look. Although a putty eraser can be kneaded to a point for 'lifting' marks, it is tacky and can leave dirty smudges. It's fine for charcoal but not much else. I cut my plastic erasers into bite-size slivers which are easy to handle and can get into crannies without erasing too much.

Use only line at this stage. Don't shade or use any sort of tone as this would encourage you to be sloppy – to fuzz over weak areas instead of learning how line can describe form as effectively as tone.

Try drawing your object a number of times in the same position, but with different tools, adjusting the size of your drawing to the size of the tool. In between (so you don't get tired of the subject), try drawing it from several different viewpoints.

If you use a charcoal pencil (as opposed to stick charcoal) or a Conté pencil, you will find that it is difficult to erase, so do your drawing *very* lightly to start with. Don't then just go over your light lines slavishly, or the vitality will be lost; treat your light drawing as a 'first draft' and make adjustments as you put in your darker lines over the top.

Before you go on to the next chapter, do be brave enough to draw your object with pen and ink. It helps to start with minute dots – not dotted lines, but enough to guide you as you draw – as I did in the ink drawing of a cobnut. Working with pen early on is very good discipline: you really have to look and think before you make a mark because you can't rub anything out.

Make sure that you don't keep lifting your pen every time you look up and don't worry if your line is a bit jagged or overlaps in places. This adds up to a personal way of using the pen and can give character to a line.

LEARNING FROM OTHERS

Now is the time to look at some really good drawings – without worrying that you'll never be as good, or deciding whether you like them or not. If some of them look odd to you, reserve your judgement until you can put your finger on exactly why they do so.

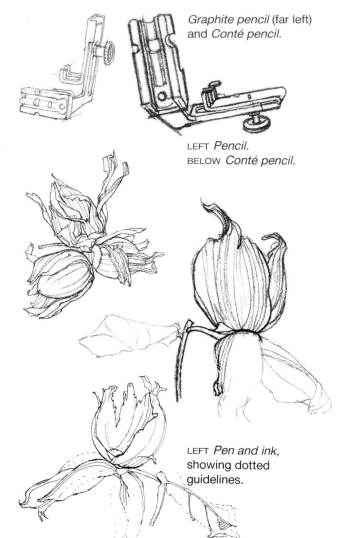

Graphite pencil (far left) and *Conté pencil.*

LEFT *Pencil.*
BELOW *Conté pencil.*

LEFT *Pen and ink,* showing dotted guidelines.

At this stage, a sensible way to look at other peoples' drawings is to look at what they choose to draw and at how they draw it – the sort of lines they make with their chosen tool, how they place their subject on the paper, how they use the paper as part of the drawing, and how they use their tools to create darks and lights. Ask yourself what the artists are trying to do. What are they trying to 'say'? Why have they used these colours, tones or textures in this way? Local art colleges sometimes have open days when students are willing to talk about their work, so you can go and ask them some of these questions.

If you visit a major art gallery, don't just look at old master drawings, like Rembrandt or Leonardo da Vinci (there are fashions in drawing, as in everything), but at drawings done by modern masters such as David Hockney, Elizabeth Frink or Henry Moore.

Some artists make 'formal' drawings. Others, like David Hockney, make drawings that seem so spontaneous they are like a non-stop method of communication. Try to think of drawings as an alternative to speech. Ultimately you will be able to 'describe' ideas and emotions as well as the physical appearance of things when you draw.

Take a lead from the professionals: draw, draw, draw, every day and everything. If you have a quarter of an hour to spare, draw something simple to keep your hand in – the way the tines of a fork join the main part, or the top joint of your own thumb, perhaps.

Remember there is no need to show anyone your drawings. If you have a partner who can see what you're doing, make it quite clear that you expect no comment while you are beginning or re-learning. After all, you are the one doing the work.

Date everything on the reverse side of the paper and put it in your portfolio. Look at the whole lot after two months and you should be encouraged to see a general improvement, even if you go backwards sometimes.

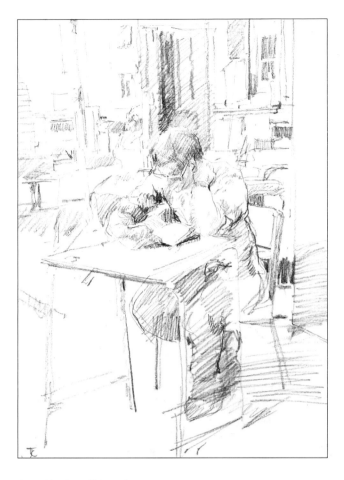

Tom Coates, 'Man at a Table'. *Pastel.* The drawing tool has been used freely, creating its own vitality.

OPPOSITE Raymond Spurrier, 'Jerez de la Frontera'. *Pen.* Although there are some solid areas of ink, this shows clearly how lively a direct line drawing can be.

project

1 Cut a tomato in half, peel and segment part of an orange, find an old wrinkled glove, or stand an iron up on end. Make three drawings of at least one of these, using soft pencil, a Conté pencil, and pen and ink. Remember to vary the types and thicknesses of line.

2 Using some tools that are new to you, experiment by combining the marks they make in various ways. Start with two tools and work up to free use of several.

3 working with tone

Now that you understand the difference between line and outline, look at this pastel drawing of a nude to see how tone can be used to show form without either line or outline.

Before we talk about tone, how did you get on with your drawings? If you chose the tomato, did you understand, as well as see, how the seeds were joined? Did you show how the skin of the orange curled as it dried? Did you manage to show how the iron is constructed or how the fingers of the glove were joined to the palm? Did you remember to change the size of your drawing when you changed your tool? You should ask yourself a lot of questions without actually judging whether the drawings are 'good' or 'bad'; just notice where the strengths and the weaknesses lie.

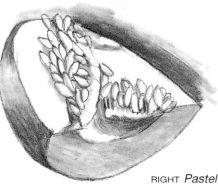

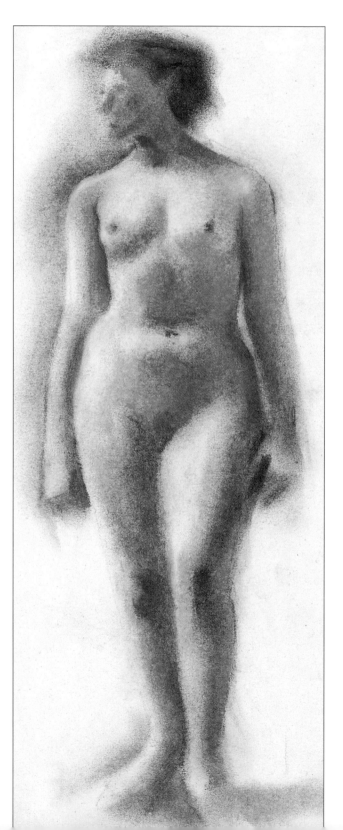

RIGHT *Pastel*. Placing tone outside the form makes a line unnecessary, as does taking the tone on the form as far as the turning away point.

ABOVE *Water-soluble pencil and Conté pencil.*

Were the new experiments you made more thorough and effective than last time? Before we put all this work together there are other experiments to be made.

As well as collecting water-soluble pencils and pens, start a collection of things that will make marks if dipped into ink or watercolour. Here are some suggestions to start you off: cotton buds, a thin twig, a toothbrush, a knife, a short piece of card. Just as you did with your more conventional tools, try out all of the things you collect and learn to control at least some of them.

Conté pencil. Part of this drawing of driftwood has been left unfinished to show the basic linear structure.

Clifford Bayly, 'Ute in Trouble and Wrecked Car'. *Pencil, oil pastel, and watercolour wash.* Areas drawn only in line are set against areas of tone.

Now try something else. Make a line and a big dot with one of your water-soluble pencils, then use your brush to put some water along one side of the line and around the dot and see what happens. Then make different kinds of marks and add water – a lot or a little – stir it around, use your fingertips and so on. Just have fun making wet marks.

Use some of your makeshift tools by dipping them in ink. For instance, put ink on the toothbrush and run the knife across the bristles towards you, so that ink splatters away from you. (Wear an overall!)

Don't try to make any images but *watch* what happens every time you do something. Cover as many sheets as you can with as many marks and combinations as possible.

ABOVE Experiments extending the variety of tools.

Experiments with coloured inks. Larger marks are made by fully loading a toothbrush with ink and making rough movements across the bristles. For fine work the finger is rubbed gently across less loaded bristles.

BELOW *Felt-tip pens.* Landscape idea.

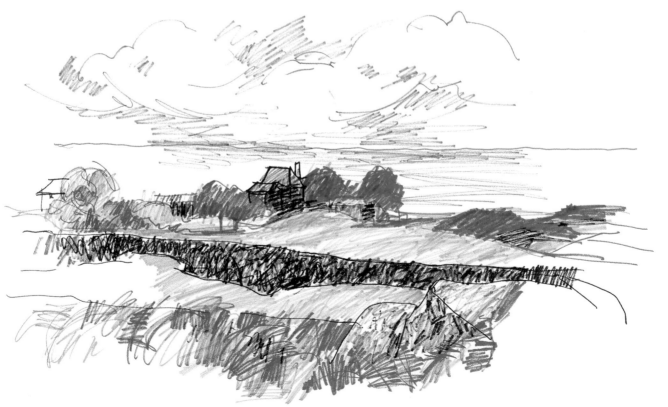

22

Sheet of random marks.

Isolating a detail using 'L' shapes.

RIGHT Charles Keeping, illustration from 'Charles Keeping's Book of Classic Ghost Stories'. *Pen, ink and chalk.* A magical, eerie mood has been created here by using tools in a variety of ways.

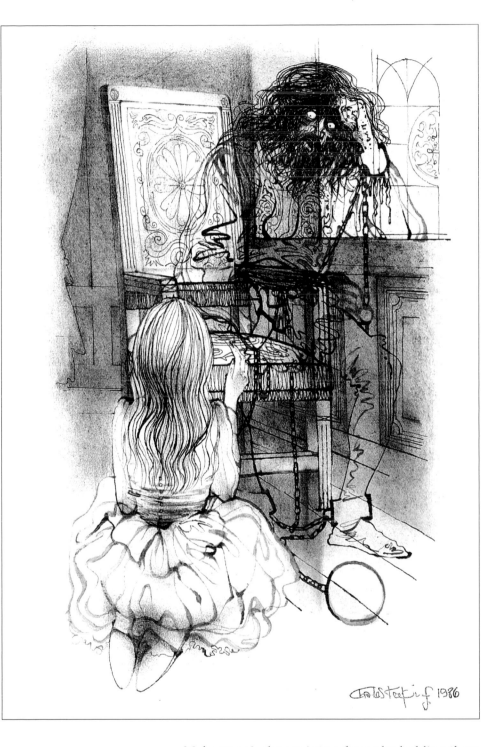

USING A VIEWFINDER

Two L-shaped pieces of card are very useful for 'framing' areas and for selecting where to limit work. Cut them out of mounting card, which is black on one side and white on the other, so that they can be reversed according to need. Make the arms about 22 cm (9 in) long and about 9 cm (4 in) wide. Two smaller pairs of L shapes made to fit into your notebooks are also a boon.

Make your L shapes into a frame by holding them together with paperclips or elastic bands and select a few small areas of the most interesting effects you've made. Draw a line around these areas and see if you can reproduce the effects deliberately and accurately. Don't worry about the purpose to which they will be put, just concentrate on stretching your tools as far as you can, so that when you come to draw landscape, people, anything, you will have an extensive vocabulary with which to describe your subject.

TONE

I will clarify what I mean by the term *tone*, as it is used differently by different people, and often leads to misunderstandings. I remember hearing a customer in a shop say that she wanted a ribbon to 'tone' with her hat. What on earth did she mean? Did she want the same colour but darker (or lighter) than the hat? Did she want a different but similar colour? I waited and listened. It seemed that she wanted any colour, of any lightness or darkness, as long as it looked good with the hat. My mother would sometimes say she didn't like a certain 'shade' or 'tone' of something (say pink). She meant that she preferred a different *sort* of pink.

'Shade' can have various meanings, such as 'to shade' – a technique used to create tone (the two words are often used synonymously) – or shade as in light and shade.

Confused? In this book I use 'tone' to mean the lightness and darkness of things; it relates to colour as well as to light and shade.

To understand tone in practice, think of a pale yellow scarf on a navy blue piece of paper. They differ not only in colour but in tone. If that yellow scarf is put on a pale blue sheet, the colours will still be different but the tones very similar, or even the same. A light blue scarf on dark blue paper will be more or less the same colour but a different tone. Do you see?

A dark, ploughed field behind a cornfield, with a pale blue sky will be a light sandwich with a dark filling! The same scene with fast-moving clouds might change quickly to a heavily shadowed cornfield with the ploughed field catching the light. Not only will all the colours change, but so will the tonal relationships. We all know this, but many give little thought to its significance in drawing.

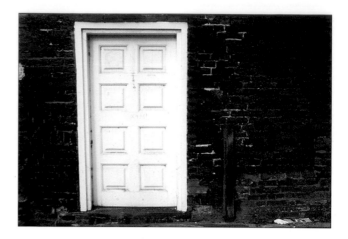

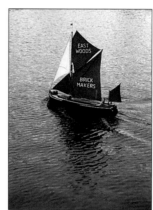

ABOVE The light door and the dark wall are different not only in colour but in tone.
LEFT The dark-toned sail shows clearly against the light tone of the water.

Moira Huntly, 'Llanfaethlin'. *Pastel pencils* create a pattern of tonal areas.

OPPOSITE Tom Coates, 'Amanda'. *Chalk on tinted paper.* Light and dark chalks have been used to suggest areas of tone in a free way which suits the style of the drawing.

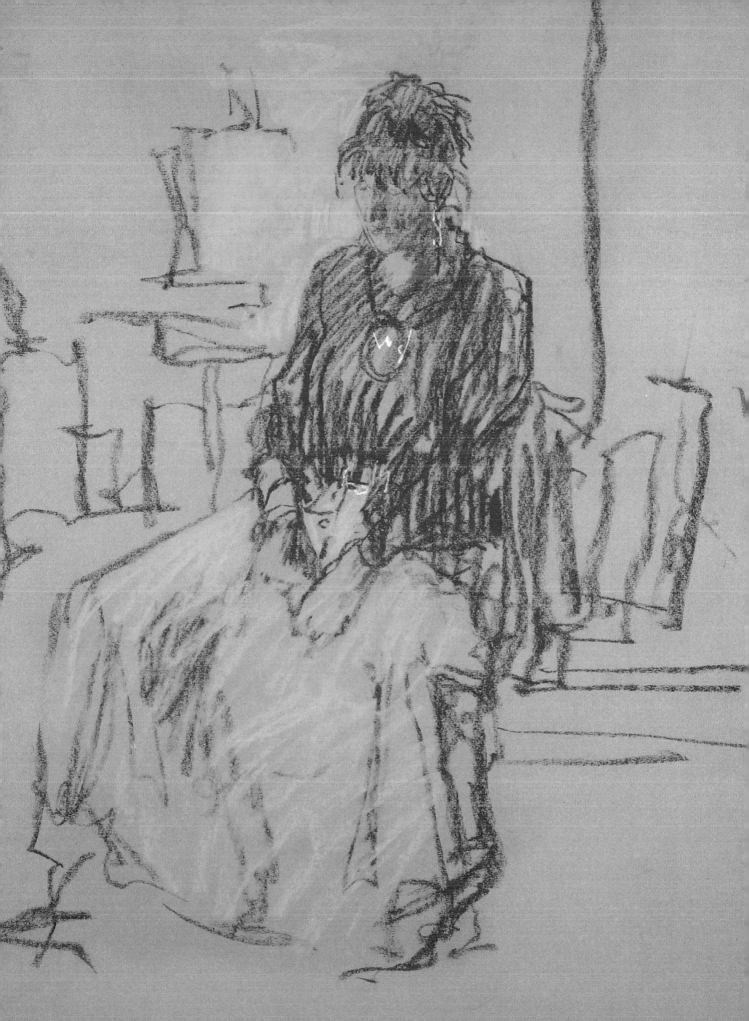

Think about using tone rather than *shading,* which is only one way of representing tone. If you think only in terms of conventional methods of shading, this will limit your range of techniques and can make for lack of variety in your work. It is much better to try all sorts of ways of creating tone so that you have a choice when you come to make exciting drawings. Compare these two pictures of cranes – different treatments of a similar subject.

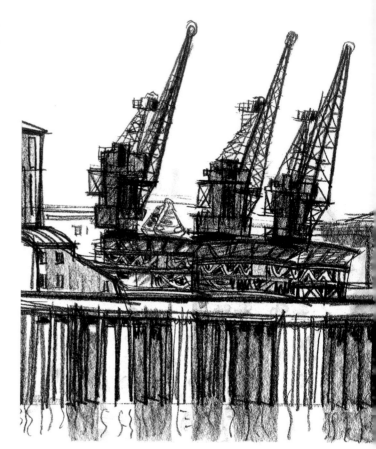

RIGHT *Compressed charcoal.* Open areas of tone emphasize the decorative qualities of the subject.

BELOW Ian Simpson, 'North Dock, Sunderland'. *Pen and wash.* Solid areas of tone create a pattern of lights and darks. The white space on the left prevents the corner from becoming too dominant.

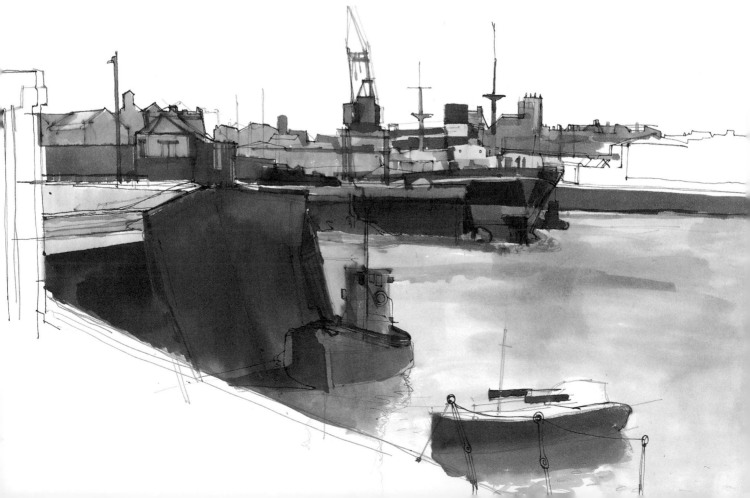

TONAL RELATIONSHIPS

Draw a square or oblong taking up about half the area of your A3 paper and within it draw a smaller oblong.

Choose any tool, decide which of the marks it made you liked best, and fill the inner oblong, fairly evenly, this way. Notice how light or dark the area has become. Now with the same tool fill the outer area with the same sort of marks made either much closer together or more spaced out. Do you see that there are now two areas of tone related to each other?

Do the same experiment with different tools, sometimes keeping the same tool and marks for the whole and sometimes changing either the tool or the marks or both. Make sure that all your tools are used so that you become at ease with using them in different ways. If you want to make two experiments on the same sheet of paper, make sure that there is enough space between your squares so that they can each be seen without being influenced by the other.

Graduating tone

By now you should have a fairly thick pile of A3 trial sheets in your folder and there are still more to come. If you get tired of experimenting all the time, try doing some careful line drawings for a change – in fact you should do this to keep your hand and eye in. It's all too easy to enjoy the 'play' part and avoid the nitty gritty, although for some people the discipline of settling down to make a drawing is preferable to what they see as dreary exercises. Both activities are essential and both should be regarded as 'drawing'.

When you are ready for some more experiments, make marks which gradually (imperceptibly, if possible) get closer and closer packed. You will see that the tone gets darker and darker. Try doing this with all your tools and the marks they make, using them singly or mixed, wet and dry, in monochrome or mixing colours. Now divide your paper into six areas (with space between each) and decide exactly how you are going to make graduated tones in each square before you start. You could fill in the first three with these methods:

1 Try conventional shading, using the side of a soft tool and gradually reducing the pressure so that the shading becomes lighter.
2 Make fairly even lines with a pen, 'cross-hatching' them at right angles to each other and letting the lines get farther and farther apart. Try a second version keeping the lines at a more acute angle to each other.
3 Fill the area with dots using one of your pencils, again working from close-packed to thinned-out.

Although the illustrations should give you some idea of what I mean, do the trial for yourself as your tools and pressures will be different from mine.

Compressed charcoal. Marks made by using a stabbing movement of wrist and elbow.

Pencil. Experiments with shading.

BELOW *6B Pencil.* African mask. Some of the construction lines have been left in.

You will probably have realized that in experimenting with tone, you have also been employing one form of texture, which will be explored in a variety of ways in Chapter 5. We shall be looking at the relationship between tone and colour in Chapter 6, but in the meantime this drawing by John Blockley shows that areas of flat colour can be used as another way of creating tone.

John Blockley, 'Salford Demolition Site'. *Pencil and pastels*.

John Blockley, 'Staithes'. *Pencil* has been used freely to create a feeling of movement and vitality.

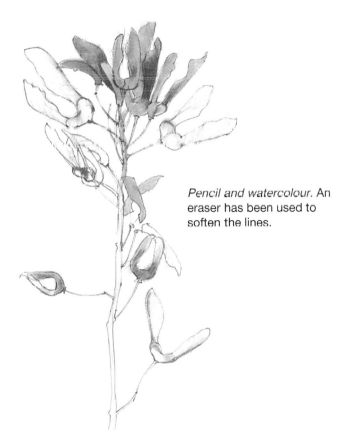

Pencil and watercolour. An eraser has been used to soften the lines.

Nicola Streeten (student), 'Arches'. *Pencil and watercolour wash.*

Pencil. For complicated subjects, use tone sparingly so that it doesn't obscure the structure.

Water-soluble graphite pencil.

project

Make a large line drawing of a tomato – or whatever you drew for the project in Chapter 2 – big enough to fill your sheet of paper or even going off the edge. Now fill in each area of the drawing with a different sort of tone, using different marks, but without worrying about 'reality'. The object of the exercise is to help you use tone by simply filling in areas to see the applied effect. This may make your drawing look very strange, but it is a good way to begin to put together what you've been trying.

Find some more objects to draw which could be filled in in this way.

4 composition

Composition is about arranging things and we do this all the time. We are bothered by imbalance, we straighten pictures on the wall, plump up cushions, arrange ornaments and generally try to establish some sort of order in our lives.

Composing elements in a frame when we draw is a kind of 'tidying up'. We do it in order to lead the viewer's eyes from object to object or from one part of our work to another until they come to rest on the main area of the drawing, the 'centre of interest'. The equivalent, in our homes, is usually a fireplace, a television set, or an area where we keep our visual treasures – ornaments, plants, or whatever.

Jean Vaudeau, 'The Black Cloud'. *Chalk*. Although the light path and curved form lead the eye into the picture, the areas of light in the sky prevent it from remaining in the centre.

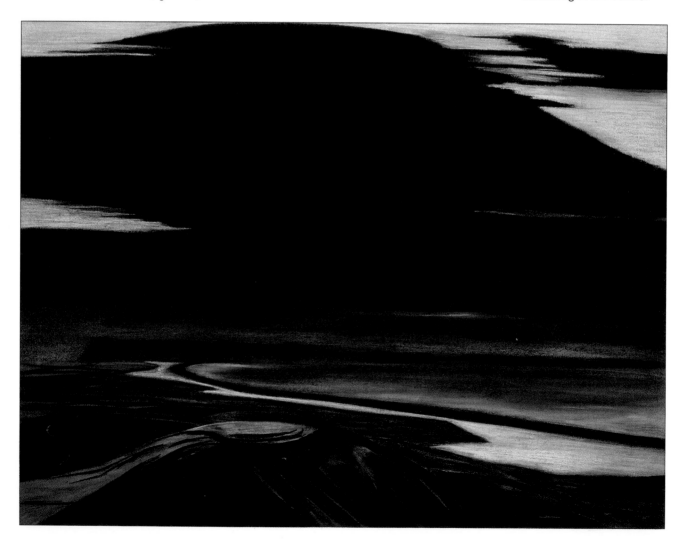

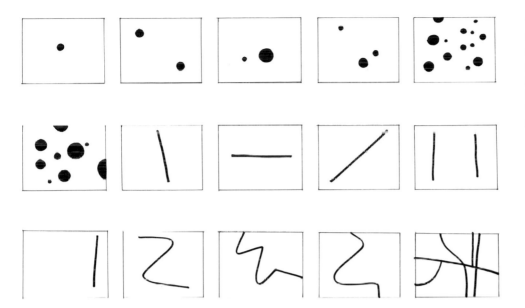

The dots illustrate the principle of weighting in composition, the straight lines represent common pitfalls, while the curving lines show ways in which the eye can be led around and out of the picture.

Complete symmetry, where everything balances equally, is the simplest, and often the most uninteresting, arrangement. There are a lot of different and more interesting ways of creating order and directing the eye where we want it to go.

Good composition is fundamental to good drawing and painting. We need to practise it and to be aware of good composition in the work of other artists, which will help us see where strengths and weaknesses lie.

Think of the millions of holiday snaps taken each year – every snap is a composition. Whenever you take a photograph, try to make sure that the composition is as effective as possible. Arrangement within the frame should be 'comfortable' and to the point – if you want a picture of Aunt Jemima on her eightieth birthday, do you need to show a great chunk of the garden as well? Always identify your centre of interest.

If you watch television with the sound turned down when you are not interested in the story, it is easy to concentrate on the images and see how the composition changes according to the importance of the characters or objects, and how directors take our eyes from one part of the picture to another without distracting us from their main concern.

These diagrams of dots and lines may help you identify a few traps and so avoid 'uneasy' arrangements. If a dot is placed in the centre of a frame, the eye goes to it immediately and stays there until interest wanes or a distraction occurs. Put in two dots of the same size and the eye moves back and forth, back and forth. Make one of those dots larger, and the eye will rest on it for a longer time.

Look at the other diagrams and work out what happens in each. With more dots of various sizes, the

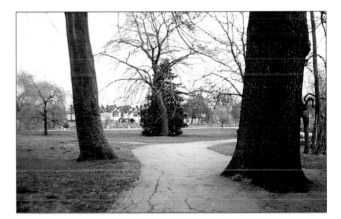

A good example of the 'bookend' arrangement; by moving the trees around, a better balance would be possible.

eye travels around, resting on some of them. Where a large dot is cut off by the edge of the paper, the eye is led back into the frame by the size, or 'weight', and placing of the others.

Lines lead the eye in a very strong way. A line across the middle divides the picture in half and creates an even but uninteresting balance. Whenever there are actual lines in your composition or linear arrangements of small objects, make sure that the eye is never led out of the frame. Where objects are placed symmetrically on either side of centre, the eye goes to and fro as if watching a tennis match; in the example shown here the central main subject is placed between two trees creating a 'bookend' arrangement. (Even worse, though, is the 'something crawling up the side' frame-within-a-frame!)

ISOLATING THE SUBJECT

When we look at our surroundings, our eyes move from object to object, up and down and from side to side, accepting the apparently random order of things. We are also aware of our peripheral vision. If we are drawing or painting a picture of our surroundings, we isolate a chunk of the view which centres on a particular object or area by putting a frame, imaginary or actual, around it.

We have seen that the centre of interest doesn't have to be in the centre of the frame and that our audience needs to look at the rest of the picture, so how do we work out how to do this?

Look at the photographs below of people standing by a Henry Moore sculpture. The camera was placed close to the iron gates and the out-of-focus circle makes a frame for the action, containing it very tightly and cutting out all distracting elements. This intensity reinforces the feeling that the people and the sculpture are related in time, however briefly. In terms of composition the photographs use a part of an object (the gate) to draw attention to the focal point. Including the whole gate would have had the opposite effect: the gate itself would have become the focal point, conveying a totally different message.

LEADING THE EYE

As an artist you must learn to direct the eye where you want it to go, and to control the amount of time the eye rests before moving on. Please make sure you understand the theory of this – it may help to analyse this city street scene – and then put your understanding into practice.

Look at this 'bare bones' drawing of a city street and see how the eye is led by the lines of the composition. At no point is it led out of the frame.

BELOW Edna Carr (student). *Chalk*. Just part of a building has been chosen to create a well-balanced piece of work.

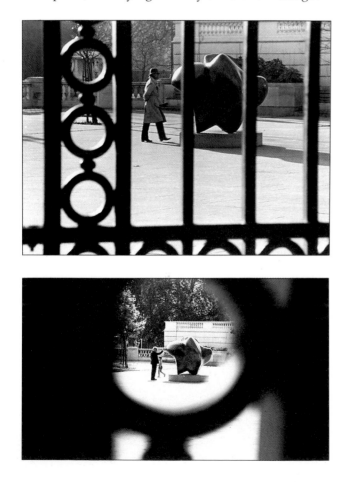

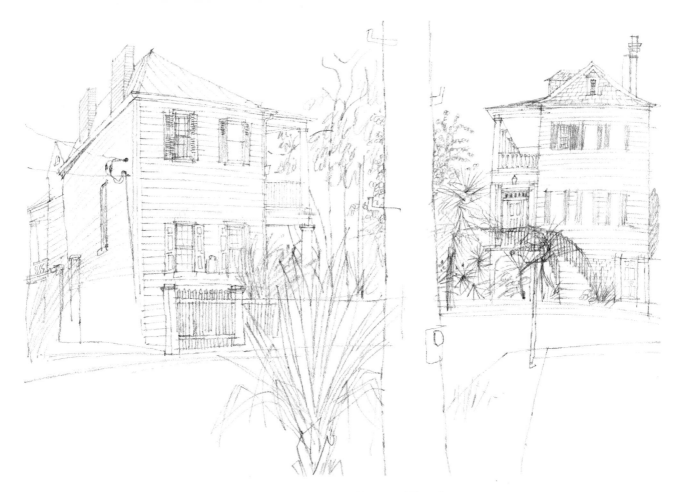

FOCAL POINTS

When a picture has centres of interest, or focal points, of different strengths, we talk about compositions being 'weighted'. These drawings by Ian Simpson and Raymond Spurrier appear to break the 'rules' illustrated by the dot and line diagrams at the beginning of the chapter, in that they are both divided almost in half, either horizontally or vertically. Yet in both cases the balance, created by the subtle weighting of the two parts, is such that the compositions work.

Raymond Spurrier, 'Charleston, South Carolina'. *Pencil*. The curved lines and textures of tree and plants help to balance this composition.

Ian Simpson, 'Tennis Courts in Wimbledon Park'. *Pencil and wash*. The perpendicular lines of the fence stop the eye from moving horizontally across the picture.

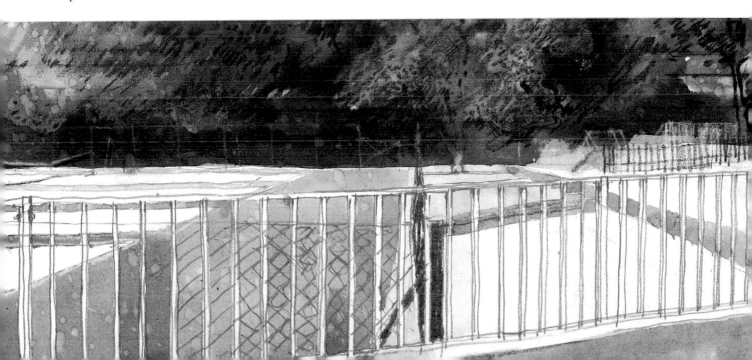

Spend as much time as you can just looking and mentally selecting things. Wherever you are, stand without moving your head or eyes and notice how much you can see in your direct area of vision and how much is peripheral. Before you move on, fasten your L shapes into a rectangle about 4×3 cm (1½×1¼ in) and use it as a viewer to block out everything except the portion you find most interesting. Try this from different viewpoints.

The relationships in a composition include not only the shapes of the objects but the spaces between and around them within the frame you have imposed. Some tutors refer to 'positive' and 'negative' shapes, the positive being the objects and the negative being the spaces in between – the 'background'. This can give the impression that negative spaces and shapes are less important than positive ones. I believe that *all* parts of a composition are positive because they are of equal importance in terms of the attention we should give them; they are part of an interdependent relationship.

BEGINNING TO COMPOSE

When you have at least half an hour, sit with your sheet of paper properly supported and draw several rectangles of the same proportion as your viewfinder but about 10×7 cm (4×2¾ in). Have a fairly soft tool ready.

Now, using your viewfinder, look around you and try to find one object, or group of objects, in the room which is more important than the others. Move the frame so that you include more, or less, of other things and so that your centre of interest is in what you think is a good place within the frame (just rely on instinct at the moment). If you are not sure at this point whether your selection is effective, don't worry, just work away until you feel more confident. Adjust the distance of the viewfinder from your eye so that you don't see too much. You should be selecting an interesting *area* not a whole view.

Draw the bare shapes of your chosen composition in your first rectangle and then do several different

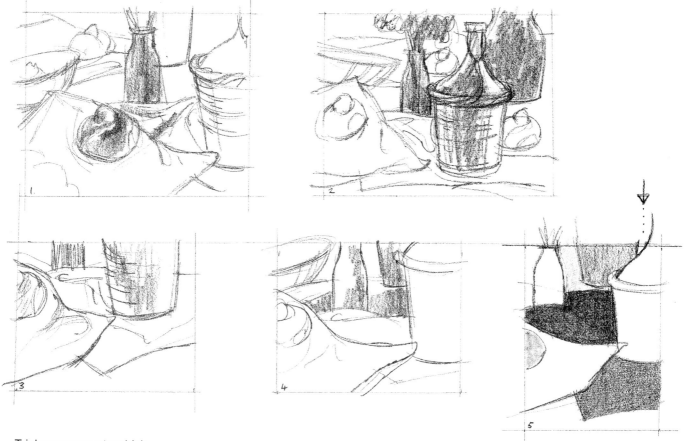

Trial arrangements which have been based on the same group of objects, with some tone added to check the balance.

compositions from where you are sitting. All of this takes some practice, especially transferring your composition to the paper so that it relates to the rectangle exactly as it did to the viewfinder.

Repeat this exercise whenever you can; don't wait until you see something you 'like', just use anything available. Begin to select natural groupings (found, not arranged) that have a main focal point and one or two secondary ones which will lead the eye around the picture.

Analysing a composition

Look at this photograph of the fire-fighters. The strong light, the hoses, and the receding lines of the building all help to lead the eye to the main focus of interest, the two firemen in the smoke. The composition is also helped by the heavy darks of the buildings leading to the light smoke. The eye tends to stay put on the firemen, although the light rectangle in the top righthand corner distracts it.

Now look at the cropped version of the same photograph. The darker area of smoke to the right of the men is almost vertical, leading the eye up to the point of the roof and to a tiny figure there. The telegraph lines and the slope of the roof bring the eye back down. Hey, presto! Cropping has achieved complete coverage of a picture with differently weighted focal points.

Although I have talked about the eye going from point to point until it reaches the centre of interest, you will have realized that in this photographic example almost the opposite happens. Most people's eyes will go straight to the firemen and then to the other focal points. Of course, it doesn't matter which way round it is as long as the whole composition is effective, conveys your message, and interests the viewer.

The word 'message' may sound pretentious, but it has a very straightforward meaning. The message can be something major or minor; it is simply what you are trying to say about your subject. In the case of the fire-fighters, the fact that there are two important focal points, either of which can be seen as primary, indicates that the men, whether on the ground or on the roof, are working together. The other message I wanted to convey was the unreal, ghostlike quality of the light and smoke. This was largely fortuitous, in that the light was just right and I happened to be in the right place at the right time with my camera; the important thing to realize is that the artist can manufacture the right time, place and mood more easily than the photographer.

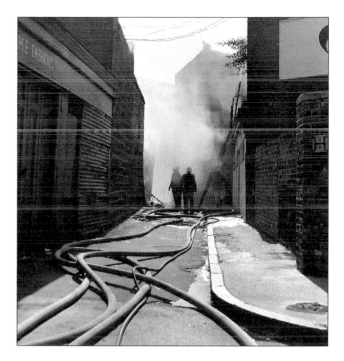

A photograph sometimes includes more than is desirable and cropping has to be done at the enlarging stage.

This cropped version is the equivalent of the final stage of deciding the most effective composition of a drawing.

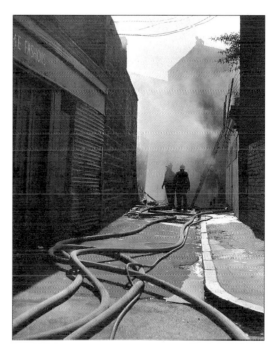

Now look at this sea picture and at the analyses of how its structure leads the eye. As you can see from the tonal analysis, this could easily have been a monochrome drawing. The linear analysis shows how important all the parts of the picture are and how they all are shapes. The rocks may have been the main interest, but everything else has its place too; without the rest, the eye would merely have gone up from the rocks to the spray at the top edge of the frame and out of the picture.

Train yourself to be aware all the time of where how and why you arrange things as you do. Learn to know why you select your subject, what you wish to communicate about it, why you decide whether to have your picture upright or horizontal, why you have chosen that proportion, and so on.

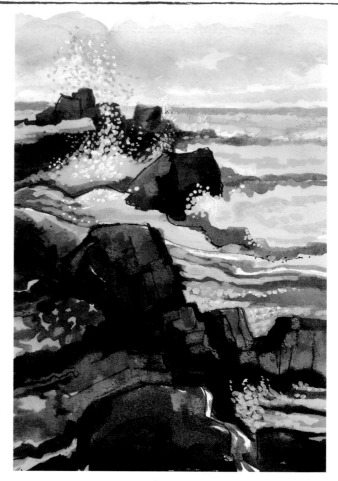

RIGHT *Gouache*. Sea and rocks.
BELOW LEFT Tonal analysis.
BELOW RIGHT Linear analysis.

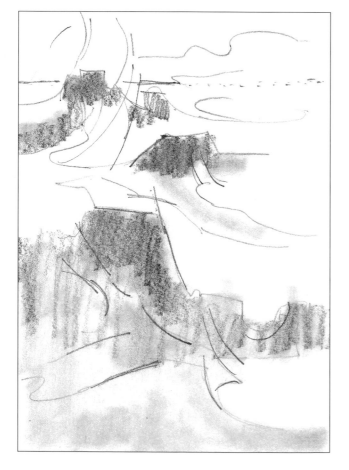

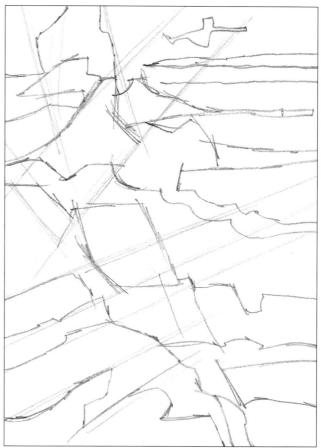

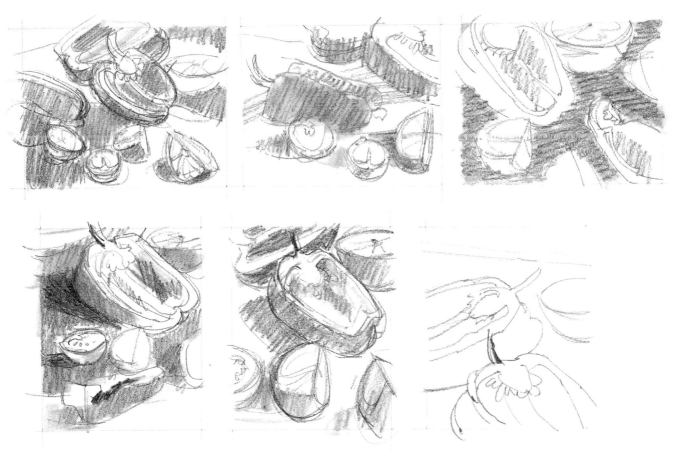

COMPOSING WITH STILL-LIFE

One of the easiest ways of practising composing a picture is to do a still-life. You can always find something around the house to make a still-life composition and sometimes it can be left undisturbed for a while, for re-thinking and re-use. Random groupings are more useful than carefully arranged ones, as they make you search for a focal point rather than contriving it.

One of the best situations is the debris left on the table after a meal – during the meal, a table that was neatly laid at the beginning tends to become untidy. Leave things as they are and look through your viewfinder. Clip the Ls together to make a long, skinny rectangle and hold it upright or horizontally. Then try a squarer format and various other proportions until you have several satisfactory arrangements.

Each time try to find a composition where one object is in a key position and others support it and will make the eye move around. For each of your chosen compositions, draw a rectangle matching the proportion of your viewfinder and block in the arrangement. Consider the shapes in between the objects and try not to let your group 'float' in your frame; don't start thinking about objects and 'background' as separate from each other. Think shapes, tones and colours.

These roughs show how it is possible to make small adjustments in the composition and yet create a totally different balance.

Choosing an interesting composition from a random arrangement is a good exercise.

Some of the objects have been cut off at uncomfortable places. Adjustments need to be made either to the arrangement or when drawing.

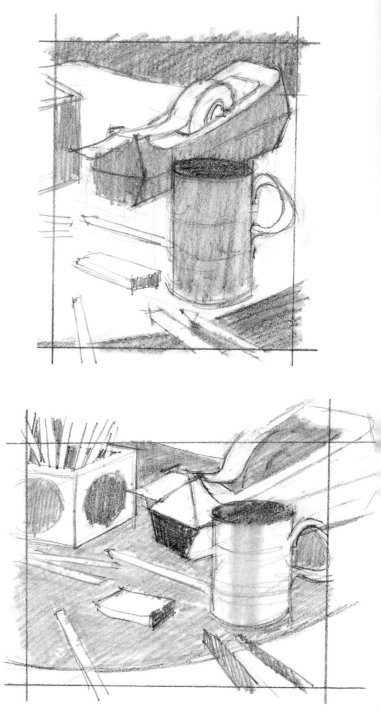

TOP Tone has been used on the objects themselves.
ABOVE Tone here has been applied to spaces between the objects.

When you have a few sheets of rough, lightly drawn compositions like these, try adding ungraduated tone to some of the shapes between the objects and the edge of your rectangle, as I have done here. This will show you quite clearly how everything depends on the arrangement of shapes. Remember that we are not dealing with still-life as such; we are using it as a simple way of practising composition. The arrangement must create good shapes within your frame, whether they are of the object themselves, the spaces between them or anything behind.

Now try placing some tracing paper over the top of some possible arrangements and do an analysis with direction lines to check where the eye is really being led, as in the picture of sea and rocks. This will help you test your instincts.

Try as many different types of groups as possible and remember that still-life can be extended to the garden shed, the scatter of tools in the garage, or whatever is available. Watch out for little traps like those illustrated here and direction lines that lead the eye out of the picture.

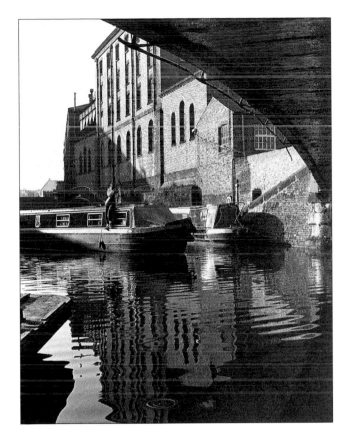

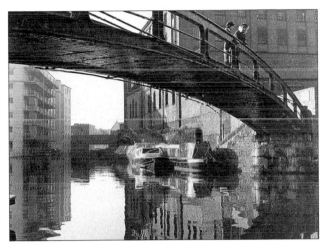

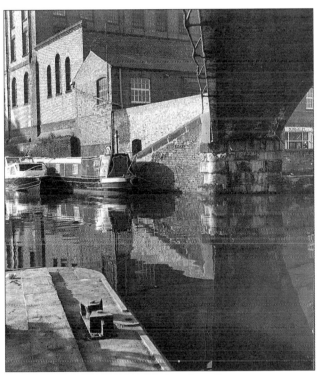

Look at these three photographs of Camden Lock in London which were taken from almost the same spot, and see how the compositions differ. It would be a good exercise to study them carefully and decide which you think is the most effective and why. Use tracing paper overlays if it helps to analyse the basic lines of composition.

ABOVE LEFT The top left corner attracts the eye, as does the top right dark area.
TOP Which is the strongest focal point, the boats or the people?
ABOVE Look at the main lines in this photograph and see how the eye travels.

tip

If you don't have any tracing paper, you can trace small areas by putting a fresh piece of cartridge paper over the work and attaching both sheets to a window with drafting tape. The light will allow you to see the drawing through the top sheet unless the paper is too thick.

In an outdoor setting where objects cannot be moved, the artist must either move to change the viewpoint or make small changes in the drawing.

project

Here is a way of putting together your experiments from the first three chapters:

1 Choose a group of objects and try different compositions. Make a few 'think sheets' of small trial runs to sort out your ideas (a bit like doing warming-up exercises). Do several on the same sheet of paper so that you can make comparisons.

2 When you find you have several good arrangements, trace off the best. Make some more think sheets, putting in areas of tone on the objects, the spaces between them or some of both. Adjust the areas of tone to create the right weighting according to where your points of interest lie and their order of importance. Think about all the possibilities.

3 If you are satisfied with some of your working drawings at this stage, then enlarge them to around A3 size, keeping the proportions right. Go on to draw the objects in a little more detail, but still keeping tone to flat areas, avoiding small bits and pieces and too much detail. We shall deal with using tone to create form in Chapter 6.

SIZE AND SCALE

Does it matter what size your drawing is? In some cases, when you are just investigating an object or making notes, no. But if you have something personal to communicate about your work, then yes, very definitely. Would you try to convey the power of a great eagle by photographing one in the distance so that it is dwarfed by its setting? Of course not. Nor would you try to show the gossamer delicacy of a dragonfly by drawing it huge against a stalk using a heavy pencil or thick black chalk.

Don't be afraid of working big, or small, or even of working big in a small format. Small drawings are not easier! And beware of getting into a habit. At the time of writing I've been used to making fairly large drawings and find it difficult to scale down to the size of a small notebook.

Use size and scale to convey your personal attitude to your subject as much as your choice of composition, drawing tools and the subject itself.

Charles Keeping, illustration from 'Adam and Paradise Island'.

Study this illustration and see how the eye is kept moving and interested.

OPPOSITE Charles Keeping illustration from 'The Highwayman'. A fine example of personal style and beautifully weighted composition. The focus is fairly central, but the balance in both tone and use of the medium holds the interest, although ultimately the eye returns to the two faces.

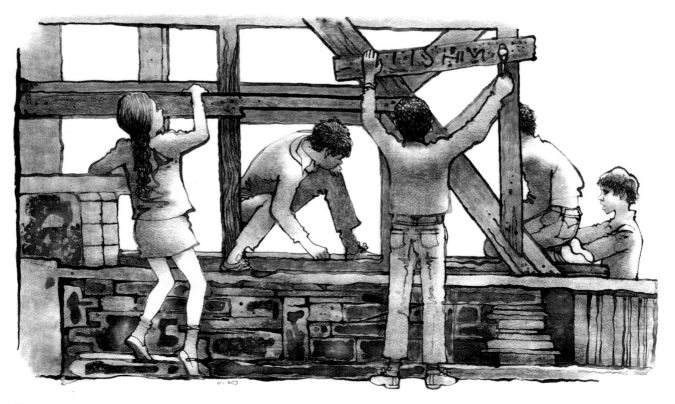

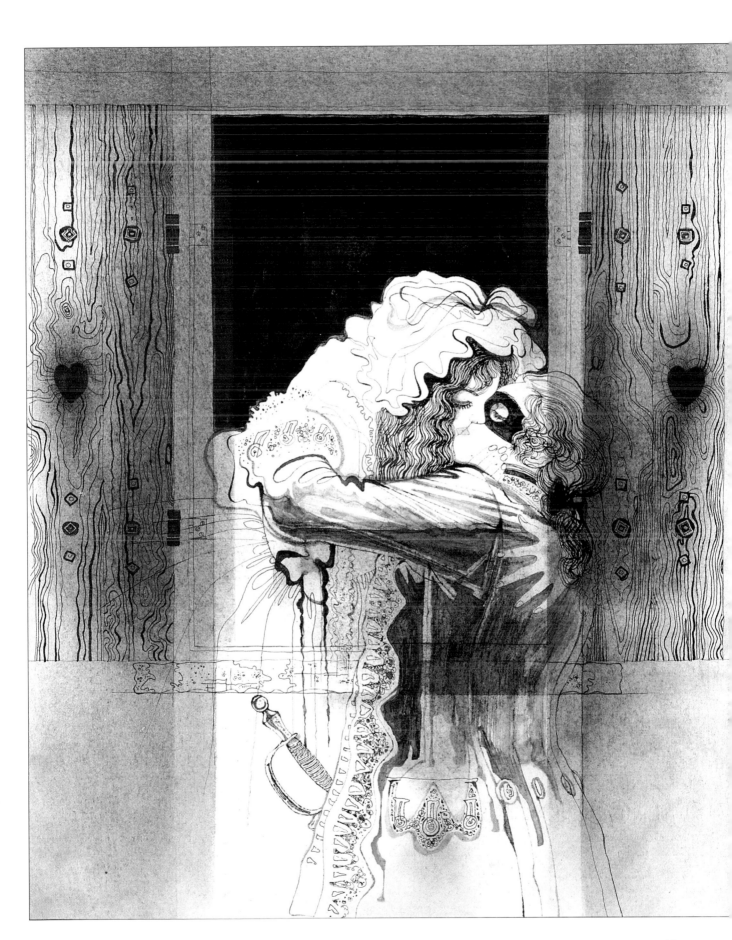

5 texture

It is amazing how few of us think about texture, although we are surrounded by it. We notice it, usually, when we touch it. We stroke soft or smooth textures like polished wood or a cat's fur and we recoil from the feeling of sandpaper or rusty iron. In both drawing and painting, though, we should become aware of texture as a visual force and a contributing factor in our work.

For our purposes we can divide textures into three different types:

Real texture
'Real' texture (one might call it 'local' texture), is that of the subject itself – a brick wall, tree bark, an area of gravel, a mass of foliage, rust on old metal, and so on.

Simulated texture
This is texture we make with our tools and media to represent real textures, or to interpret them in some way. Few people would feel the need to draw, say, every leaf on a tree or every blade of grass, so a way has to be found to represent them as a textured mass.

Real texture. Note the colour of the shadow.

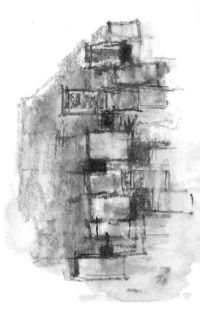

Oil pastels, watercolours and pencils simulate the texture of bricks.

The textural quality of wood is clear in this close-up.

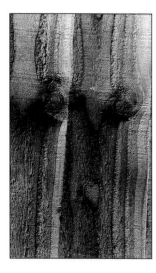

Coloured pencils and graphite pencil simulate the texture of grass.

Invented textures

These are made by being inventive with your tools and media – as we have discussed in previous chapters – to make different tones or masses. Sometimes, as with paint, these effects appear to have a tactile quality. This happens when the tool or medium has been exploited so that its inherent qualities interact with the surface of the paper.

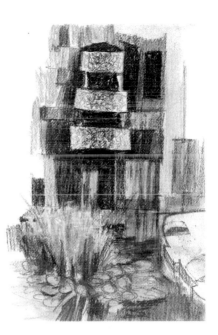

RIGHT *Pastel on very rough watercolour paper* simulates the texture of the stone.

Alan Hume, 'Harmony'. *Coloured pencils*. The textures of plant and brickwork are set together with great delicacy.

EXPERIMENTS

Using any tools you have, try to create exciting textures. Make both simulated and invented textures of three subjects and then go on until you are not at a loss when faced with any new textural problem. Try to make each texture in two or three different ways by using different combinations of tools.

Here are some ideas to start you off:

Simulated textures

Rough gravel and pebbles
A piece of knitting
A mass of leaves

Don't worry about 'copying' or being exact. Just try to produce a texture which suggests the real ones.

Invented textures

Scratchy and blobby
Wild and woolly
Mysterious and ominous
Light and joyous

You may need to have several small tries at this before you decide how to develop your ideas.

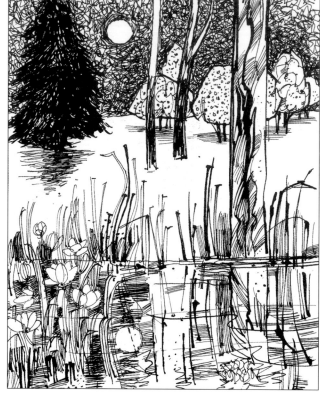

Pen and ink. The texture is created by the inventive way the pen is used, suggesting mood through tone.

Oil pastel, pastel, water-soluble pencils, inks and watercolour are used to suggest 'invented' textures of undergrowth, rocks etc.

Pastels on a very rough watercolour paper. A large brush loaded with water was washed across the surface.

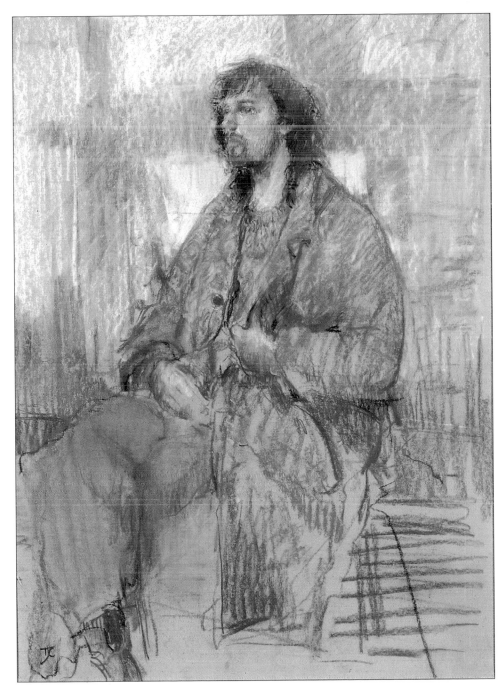

If you want to protect small areas of your work from being splashed or overlaid with ink or wash, buy a small jar or bottle of masking fluid from an art shop. Paint it on with a brush over the area to be protected, leave it to dry, then carry on with your work. When you want to remove it, simply rub off the masking fluid with a (clean) finger. Do this gently or it could rough up the paper surface.

As masking fluid is a rubber solution, it will ruin your brush if any dries in. It helps to rub the brush lightly on a cake of soap before using it and then rinse it thoroughly as soon as you have finished. If for any reason you can't rinse it immediately, leave the brush in water until you can. Take care to keep the masking fluid away from your clothes.

ABOVE Tom Coates, 'Man with a Beard'. *Pastel.* The texture of cloth is suggested in a very subtle way and is enhanced by the texture of the pastel itself.

The white areas were made by leaving the masking fluid on until the end. The fluid can be rubbed off at any time as long as the surface is dry.

OPPOSITE Charles Keeping,
illustration from 'Beowulf'
by Kevin Crossley-
Holland. *Ink and chalk.*
This is a 'low-key' work in
that the tones are fairly
close and dark. The
drawing creates a real
feeling of moonlit mystery.

Clifford Bayly, study for
'After the Hurricane'.
*Pencil, oil, pastel, and
watercolour.* Soft colours
and gentle textures
suggest the calm coolness
after violent weather.

MOOD

Do you see how invented textures can help to create a
mood or atmosphere? Take some simple shapes –
apples, pears or just abstract shapes – and compose
them comfortably in a rectangle in such a way that
you create other shapes between them and the
frame. Remember what you learnt about centres of
interest and leading the eye in Chapter 4. See every-
thing as shapes to be filled with invented textures,
they don't have to be 'real'. Trace off your design on
to a second sheet and decide what sort of mood you
are going to create for each; one could be an 'essay' in
a soft and mysterious mood and the other in a menac-
ing mood, for example.

These experiments will only be partially effective,
as the subject matter may not be appropriate to the
mood you are trying to create, but they will show you
how expert you are becoming in using your tools and
your imagination.

Just because you are practising something new,
the previous experiments shouldn't be forgotten.
Whatever you do, don't say, 'Oh, I'm only practis-
ing, so I'm not bothering about . . .' Do get into good
habits and let your learning be cumulative.

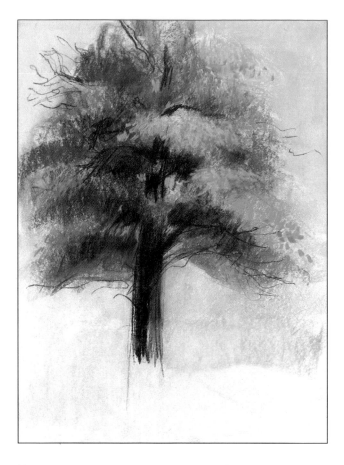

Pastel. Tree showing masses of foliage.

BELOW *Pastel pencils.* Group of trees with masses of light and dark set against each other.

TEXTURE AND TONE

Now is the time to go outside or look out of a window and make a complete drawing of something with a textural content, like trees, grass or gravel, or a building site where there is plenty of natural texture. Don't worry if your drawings of trees or greenery aren't up to standard, just have a try.

When you are dealing with local colour – that is, the colours of the objects themselves – you should have no problem creating the textures you need once you are used to using your tools. The bigger problem is in dealing with masses of texture, such as the foliage of trees, where some areas are darker than others. If you squint at your subject through half-closed eyes, you will find that this cuts out small details and gives you a clearer picture of the way light falls on masses. Usually just making your texture darker and heavier or the marks closer together will be effective.

OPPOSITE *Pastel, oil pastel, water-soluble pencils, coloured pencils, and watercolour graphite.* All these drawing tools have been used with vigorous arm movement to create a feeling of wind and motion.

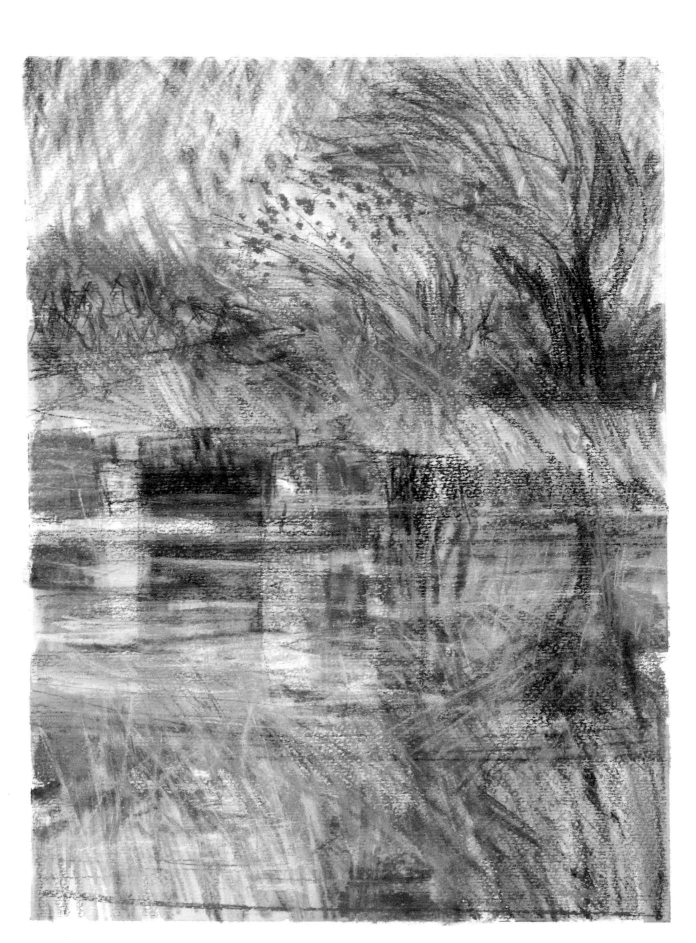

If you use more than one tool in a drawing be aware that the textures they make can quarrel with each other and look at odds. This drawing by Moira Huntly shows how different tools can be combined successfully.

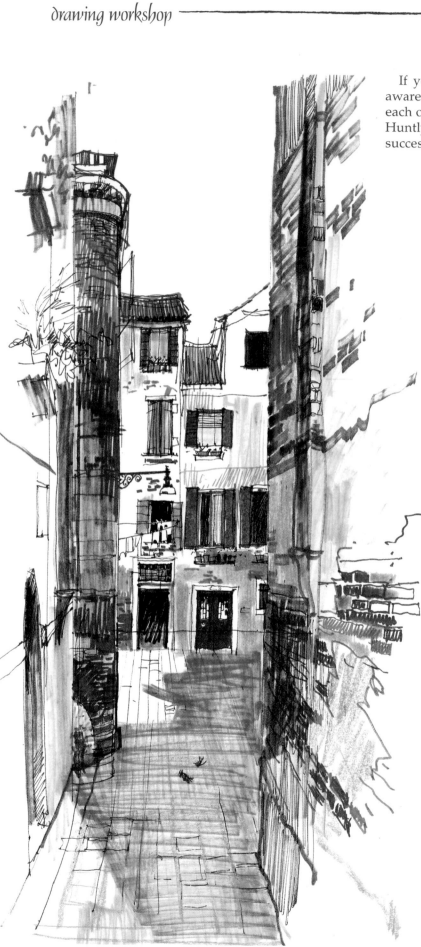

Moira Huntly, 'Campiello'. *Pen, felt-tips.* Different tools are used in harmony to create the texture of old walls.

DEVELOPING STYLE

Most of us take for granted the fact that we can recognize an artist's work just by looking at one painting because they have a distinctive, personal style. The same is true of drawings, especially those by artists who draw as an end in itself rather than just making notes or working drawings. Style cannot be learned (unless you are imitating someone else's, and that's not on); it gradually develops.

Clifford Bayly, 'Bank of Trees'. *Pencil, watercolour, and oil pastel.* The fascinating use of tools gives a feeling of lightness and movement to the tree, and small blocks of colour add to the feeling of delicacy.

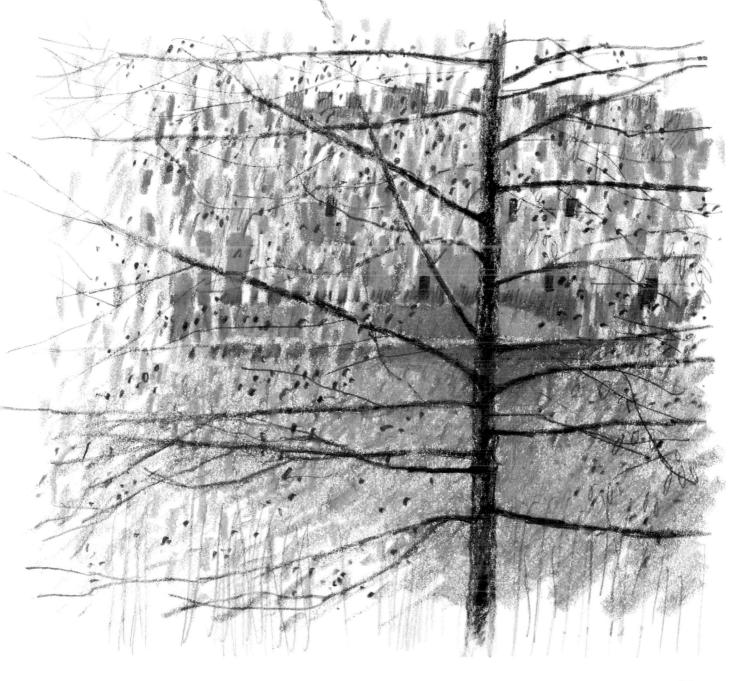

You will find that as you do more and more drawing you will stop being over conscious of your tools and begin to be yourself and have something valuable to say. If you have nothing to communicate except, 'This is like this,' or, 'Aren't I good at handling my tools?' there will be nothing personal in your work and nothing to distinguish it from a million other competent but uninteresting drawings. Your drawings should not only be technically sound, but show a passionate dedication to attitudes and ideas.

The amount of white paper that is left untouched within the frame of a drawing is a contributing factor to style. Do look out for it in the drawings in this book, as it's something we don't usually notice. Like texture, we seem to take space for granted or see it as 'background'.

If you are making a drawing in monochrome, for example, and you do not need to fill the whole of your frame with marks in order to show what you want, then the paper which is left clear will be part of the composition just as much as the rest, helping to balance it and lead the eye. It will also be a vital resting place for the eye. White space can enrich a drawing, but it must be considered as carefully as all the other elements.

The use of space is a subtle problem that arises as soon as students start deciding just how much to draw and how much to leave out. It is especially noticeable when tools are being used to create areas of texture which would be intensified by being set off by plain areas.

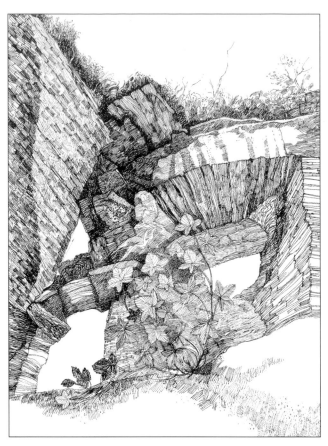

ABOVE *Pen and ink*. A fairly 'high-key' drawing, which is generally light and even in tone.

BELOW *Pen and ink*. Design for a greetings card.

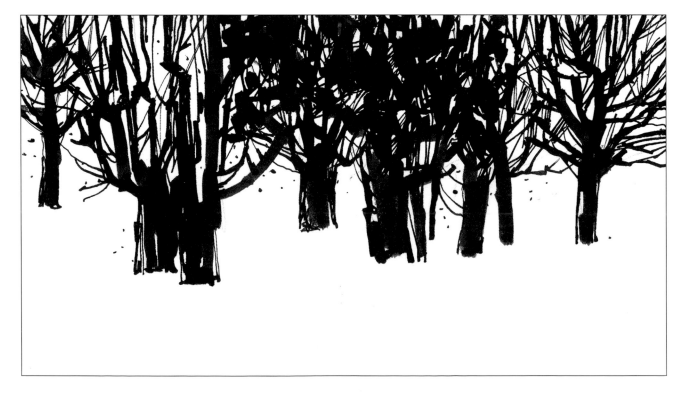

Find a subject which you would enjoy drawing and that has plenty of textural interest. This will be your first major piece of independent work which puts together many aspects of your learning. Make your drawing A3 size or bigger if you are using big tools. Support your paper properly on your board and sit well balanced.

Try a second drawing using only a part of what you have drawn and place it on the paper in such a way that the white space becomes part of the composition, making sure that the amount and strength of the texture is balanced by that space.

LEFT Alan Hume, 'Mechanical Profile'. *Pencil*. An effective use of paper space balances the drawing, which does not need to fill the frame.

Alan Hume, 'Original Features'. *Pencil*. There is a fine balance between the amount of space occupied by the drawing and the paper that has been left untouched.

If you lack confidence in this, make a drawing with a lot of texture in it, filling a long, thin oblong of paper. Take another sheet of paper – the same length but wider than the drawing – and move the drawing about on it until it is comfortable in its new 'frame'.

Providing your choice of subject and attitude are truly yours every time you make a drawing, you will find that a thread of something or other, often indefinable at first, runs through many of them. Gradually a characteristic look will appear in your drawings, as it does in handwriting. This is the beginning of a personal style.

Every time you begin a piece of work, remember to consider centres of interest and where the eye is led; textural variation; what to put in or leave out, which proportion works best – long and skinny, upright or horizontal, short and fat (don't be influenced by the proportions of your paper). Think about using black and white or colour, and suit your tools to the intention and subject of the drawing. For example, heavy black chalk would not be appropriate for a field of delicate poppies, but might be right for big, blowsy, cultivated ones.

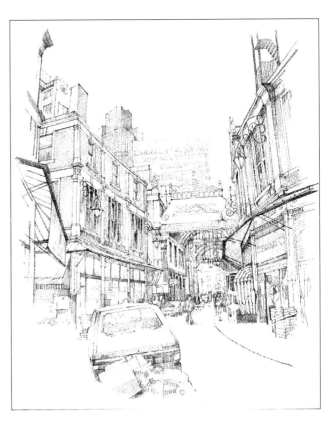

6 light and form

Now that you have a good foundation knowledge of tone and composition, it is time to talk about tone in a different context – as a means of giving solidity to three-dimensional objects. Wherever there is a light source, whether this is natural sunlight or artificial illumination, there will be shadows, and where there are shadows and shadowed areas, there will be a need for tone in your drawings. The strength and the treatment of that tone will depend on the intensity, direction and clarity of the light source.

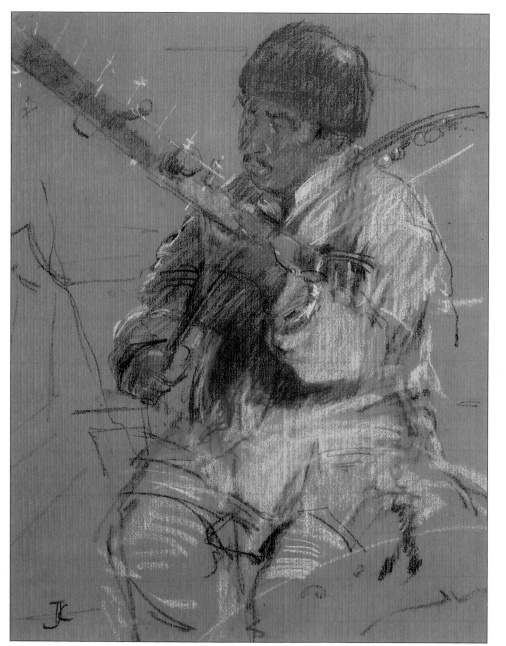

The strong sunlight of an early autumn morning makes a foreground contrast to the bridge still in mist.

Tom Coates, 'Indian Musician'. *Pastel* has been used in a lively, free way, and suggests light and shade as well as the feeling of movement.

REFLECTED LIGHT

Now take two simple rounded objects – I suggest a pale fruit like an apple and a straight-sided light mug. Set the apple on a sheet of white paper or a white cloth against a medium-toned wall and then set the mug on a medium-toned ground against a background of white or light-toned paper. Look carefully.

If the light is coming from one side slightly above the apple, it will cast shadows on the ground as well as on the wall behind the apple. Since the ground is very light, this will reflect some light back on to the underside of the apple and will create an area of curved (because the apple is curved) light, which interrupts the shadow on the fruit. You will find a similar thing happens to the side of the mug set against the light background. This is what we mean by 'reflected light'. The effect occurs in many situations – do you remember, as a child, holding a yellow flower, like a buttercup, under someone's chin and seeing the golden glow reflected there?

Now do a series of experiments with different but fairly simple forms such as an egg, a pear or a billiard ball, in different light intensities. Then move on to groups of shiny and matt things against and on different toned surfaces. Note that one object can reflect light on to another object. It can get exciting at this stage if you are really grappling with the problems of light and shade.

ABOVE The dark shadow on the apple is interrupted by the light reflected by the light ground.

The reflected light on this cylinder can be seen very clearly.

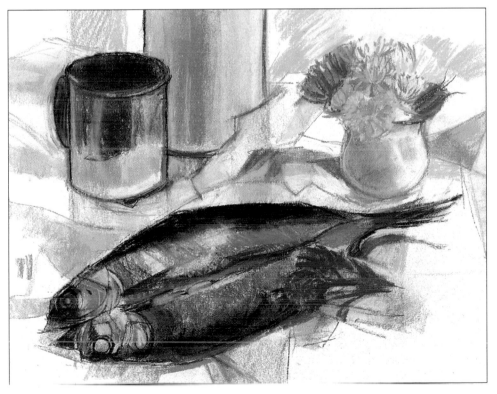

Pastel. There are examples of reflected light in all three pots.

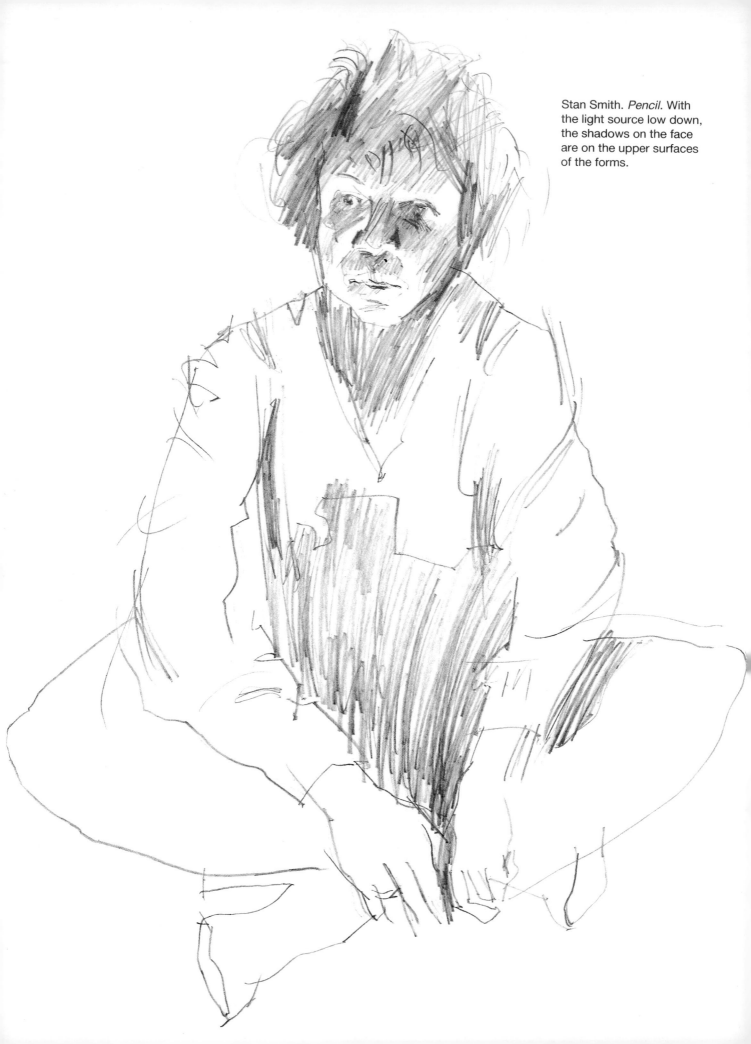

Stan Smith. *Pencil.* With
the light source low down,
the shadows on the face
are on the upper surfaces
of the forms.

Without going into the theory, I suggest that you draw two large cubes, filling each of the visible sides with a different tone, using a different tool and method for each one. Do the same thing with the second cube but change the tones and methods around. When you look at your drawings you will find that there is a suggestion of directional light according to where you have put your lights and darks.

Now try graduating tone from very light to very dark, as you have done before, on two drawings of a large cylinder, using different drawing tools or media and different methods.

Some of your textures may make the cylinders and cubes look rough or woolly and you may feel you should revert to conventional 'smooth' shading. It is not a good idea to do this at the moment, as you would be opting out of vital experimentation which will widen the scope of your work and help you to deal in all sorts of ways with light and dark tones, both even and graduated, when you need them.

The next step is to understand how light and shade work. Light, of course, is what enables us to see the form of anything, its solidity in space and the depth of space itself. *Form* is the word used to describe the solidity of objects and their three-dimensional quality. A circle, for instance, has no form, as it is two-dimensional, whereas a ball has; in fact all objects in space have form, although the forms of chairs, ornaments and so on are less easy to describe than the spherical form of a ball.

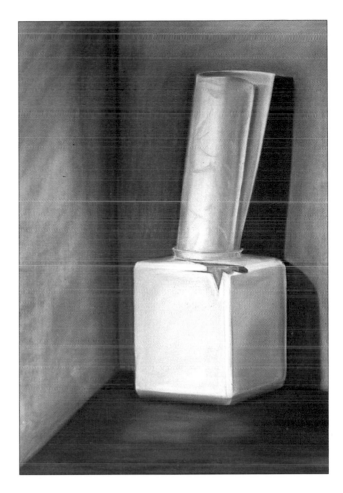

Jean Vaudeau, 'Cylinder and Box'. *Chalk.*

DIRECTIONAL LIGHT AND SHADE

This aspect of light and shade is the easiest to understand. Take a plain, light-coloured mug or cup and place it fairly close to a wall, in the path of a light source, like a table lamp. The light-to-dark effect on the cylindrical form will be seen quite clearly. Now look at the shadow falling on the surface and on the wall behind. Note the shapes and any differences between the tones on the two planes.

Can you see that the shadow is 'attached' to the object and takes its shape from it? The object will appear to 'float' if you leave a gap between it and its shadow – remember Peter Pan! Notice the density of shadows and how their appearance and tone change according to the surface on which they fall.

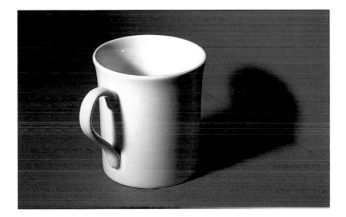

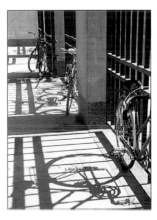

LEFT The shadow of the handle as well as the shadow of the mug itself follows the form of the object on which it falls.

Notice how the shadows are attached to the bicycles and are affected by the perspective of the ground.

Alan Hume, 'Patterns on the Road'. *Coloured pencils*. A fine example of the way shadows take their shape not only from the object but also from the direction of the light.

TONE AND COLOUR

Draw a group of objects using a black tool like compressed charcoal. You will have to decide whether to use tone to show light and dark colours or whether to use tone for the form only. For example, do you use tone all over a dark object to show that it is a darker colour than its neighbours, or do you ignore the colours of the objects, since you are using monochrome, and just concentrate on the tonal relationships of light and shade?

This problem has been argued many times and there is no 'right' answer. If you are a purist and use tone only to show form, the colour of the objects is irrelevant in a monochrome drawing. You will just have to make up your own mind whether you also want to use tone for dark and light colours. When you are working in colour, of course, there is no problem, but make a drawing in both ways so that you can compare the results. It may help to look at what the artists in this book have decided to do.

If you are fairly advanced in your work, you could try a self-portrait (as well as other subjects) in an interesting lighting set-up. This need not be complicated to arrange. If you put a table lamp on one side of your subject and a piece of brightly coloured paper on the other, the colour of the paper will reflect back and will change the colour of the shadows. Also try your light source below or above your subject.

This photograph of a staircase shows clearly that shadows have shape and perspective. We shall be dealing with perspective later on, but in the meantime look carefully at the shapes of shadows cast on the ground or a flat surface behind or to one side of the object. When shadows fall on other objects they follow the form of that object just as patterns do.

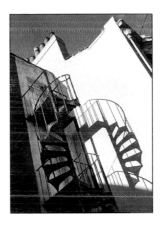

Instead of being projected on to the ground, these shadows follow the plane of the wall, so they do not appear to be attached.

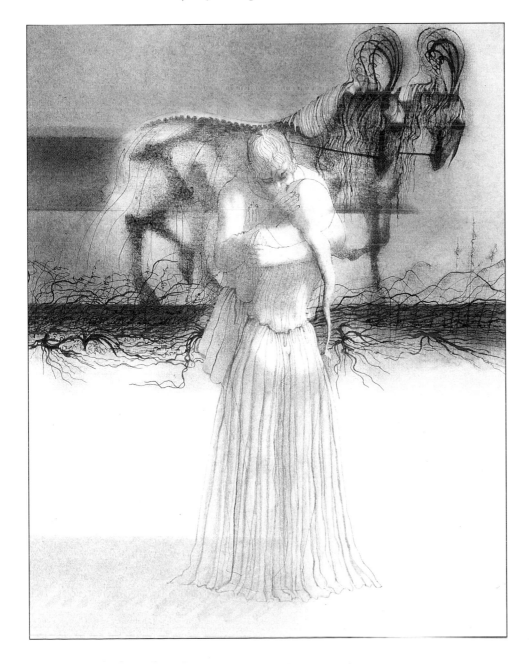

Charles Keeping, illustration from 'The Lady of Shalott'. Shadow is used imaginatively rather than realistically, and defines the forms of the figures.

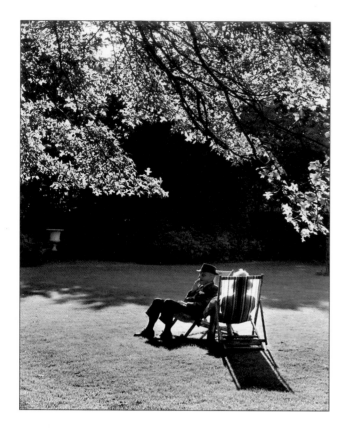

Notice the rim-lighting around the man and how the figure of the woman is dark against the transparency of the deckchair.

CONTRE-JOUR

This is the term used when objects are set against the light. The effect can be very beautiful: the objects may be quite subdued in colour and tone but have a rim of light around them (in fact, in photography this is called 'rim lighting').

Why not try drawing a group of still-life objects in front of a window? Look very carefully at the tones with your eyes open normally. What happens? Think back to the chapter on composition where we talked about the way we see and our peripheral vision. We may see the curtains, the sill, perhaps a view outside, and lots of light as well as the objects themselves, because our eye travels around. If the curtains and walls are light, we won't see the overall effect of the back-light as clearly as we would if we had our eyes nearly shut against the brightness. Try it. Squinting reduces details and simplifies contrasts, which helps you see the relative, general tones of curtains, objects, shadows, and so on. Everything will look darker. Have you ever taken a photo of someone against the light and been disappointed that the result is almost a silhouette? Well, this is the equivalent of the camera squinting against the light.

Reducing complications in this way will help you decide how much detail is necessary to show what you want to show. Ask yourself whether it is the overall effect of the back-lighting or its effect on a limited part of the group that interests you. Do you want to create a rich, velvety effect or a delicate, gentle one? Whenever you make a drawing which is not intended as a specific experiment or learning exercise, remember to make up your mind exactly why and how you want to treat it. This will guide your choice of paper, tool, and technique and contribute to your growing personal style.

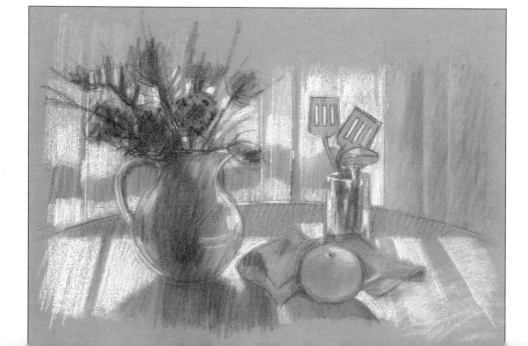

Pastel. Look carefully at the colours of objects silhouetted against the light.

OPPOSITE Tom Coates, 'The Foreman'. *Pastel on tinted paper.* Light is suggested by the addition of white, which also suggests the colour of the clothes.

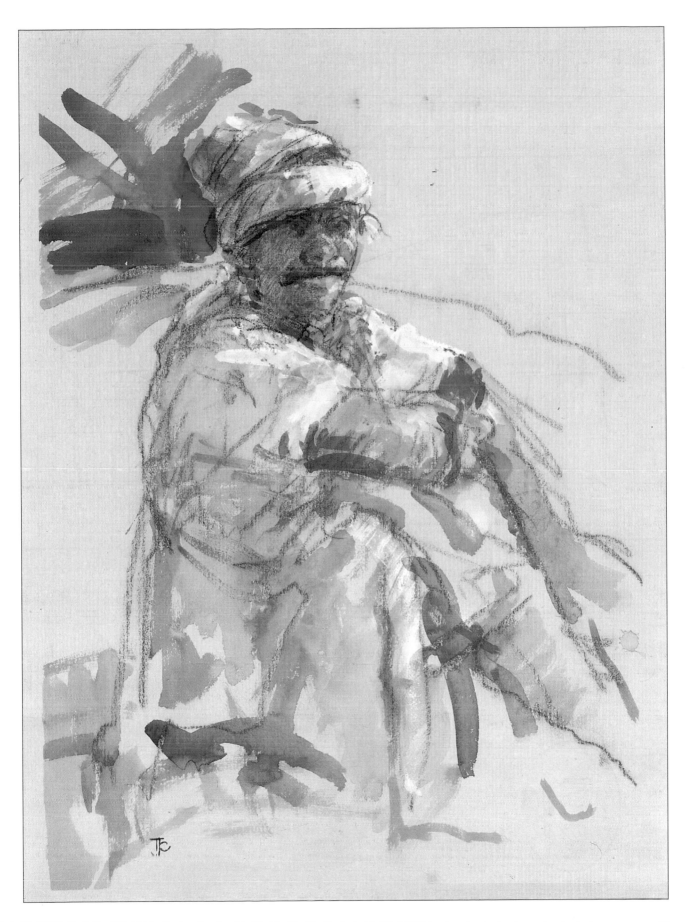

FORM AND DECORATION

In Chapter 2 I talked about the effect of form on 'out-
line'. If you are finding this difficult to understand,
now is the time to clarify it. Look at this drawing of
folds. Several points are illustrated here. Tone isn't
actually necessary to describe form (although it may
suit your purpose to use it in this way), but it *is* neces-
sary in order to describe light and shade.

 In future try to use tone where it is necessary. Set
yourself some problems of folds and draw them,
with and without tone, using different tools.

 The decoration of any object, person or animal will
always follow the form and will be affected by light
and shade as much as the object is itself. This applies
to the stripes on zebras, the patterns on the clothes
we are wearing, decoration on mugs or vases, and so
on. Far from making things more difficult, if the dec-
oration isn't too complicated it will help us describe
the form, as in this drawing of a mug – but don't get
so caught up in the intricacies of the pattern that the
effect of the light is forgotten.

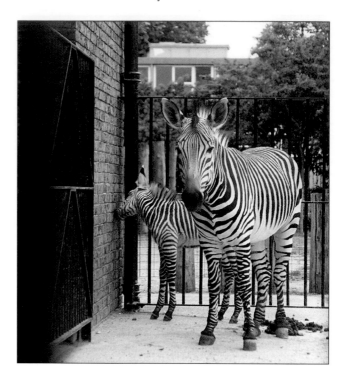

Since stripes and patterns
always follow the form of
the object, it is easier to
see the complexity of
animal structure on a
zebra than on animals
without strong markings.

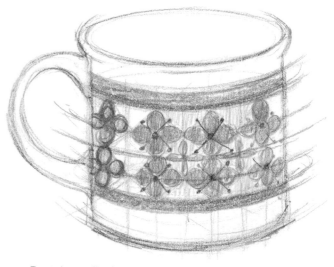

LEFT *Pastel pencils.* Apart
from the interest of the
folds, this drawing shows
some rim-lighting,
reflected light and
directional light. There is
minimal use of line to
show form.

ABOVE As well as following
the form, pattern is
affected by the
perspective of the object.

PERSPECTIVE IN STILL-LIFE

To help you with all these still-life drawings, let's look at some aspects of perspective.

Ellipses

Hold a straight-sided mug so that the top is at eye level. The rim will appear as a straight line and the bottom will be slightly curved. Now put the mug on the floor at your feet. Its bottom will be a circle. Next, hold the mug at different levels from knee-high to above your head. See how the depth of the curves of the top and bottom change as the mug is moved – the higher or lower the mug is, the deeper the curves. Repeat these experiments with a glass, and you will see both bottom and top ellipses quite clearly. Note that there are no sharp points in an ellipse. Look at the small drawings here to check your observations, but don't skip doing the experiments for yourself.

If you are finding it hard to draw a good ellipse, are you holding your pencil so that you have free wrist and elbow movement? Re-read p. 12 and look again at the way you sit. Swing your hand in loose curves – not too big at first – and fill pages until ellipses come easily.

To draw a good ellipse with a pen, practise with pencil first and then you will be able to use your pen with confidence, instead of having to 'go over' a pencilled ellipse. Going over any line gives a dull result. Always do initial drawing with the same tool and medium as the finished work.

Books and boxes

One of the principles of perspective is that all lines moving away from you appear to 'meet' at a point at eye level, known as the vanishing point. When you are drawing books or boxes, this effect will not be extreme because the objects are small, but it must be taken into account.

Jean Vaudeau, 'Vase of Daffodils'. *Chalk*. Ellipses in action.

Freehand ellipses.

RIGHT The effect of eye level on ellipses.

63

SPACE

If you have really got to grips with composition, you are probably now thinking of spaces as part of the whole. But you will have begun to perceive another aspect of space while you were practising ellipses: how an allowance must be made on a two-dimensional surface for the space an object occupies in three-dimensional 'reality'.

Once you are aware of the problem of spatial perspective, it is easy to solve if the group of objects is in front of you. If you are working from the imagination, however, you will have to rely on previous observation, practice and understanding. When you are faced with a street scene, or anything where there are free-standing forms related to others, notice exactly how objects relate to each other on the surface or on the ground.

TRANSPARENCY AND THICKNESS

People get really anxious about drawing or painting glass because they label it as such and think that transparent things must be difficult to draw on an opaque surface with an opaque tool. When our mind is anxious, it undermines confidence, often preventing us from thinking straight. Just try to draw what you see and decide first whether to use tone for the colour or for light and shade. If the latter, leave any real highlights as white and then assess the range of tones necessary for the rest. If you are clear about your objective, you will not find it too difficult.

If you are drawing in line, the thickness of the glass should be drawn, and, of course, anything that is behind. If bottle glass is distorted, then what you see through it will be too. Any shadow cast will vary in tone according to the thickness of the material casting the shadow and will therefore echo the variations in any glass or transparent objects.

With *all* objects, the thickness of their structure must be shown – the thickness of a cup, a screw-cap on a bottle, the edge of a box. Lots of people forget this and end up with paper-thin objects!

By now you should be making quite serious drawings of still-life groups of all types if you have worked through the last chapter as well as this one. Always use various combinations of tools and media so that you become at ease with them all. But don't think that still-life is the only subject appropriate for working with light and shade. Look around you wherever there is a strong light source, notice its effects and draw whenever it is possible.

OPPOSITE Jean Vaudeau, 'Still-life with Glass'. *Chalk*. Notice the thickness of the objects and how the shadows show the transparency of the glass.

BELOW Pencil drawings showing the thickness of different structures.

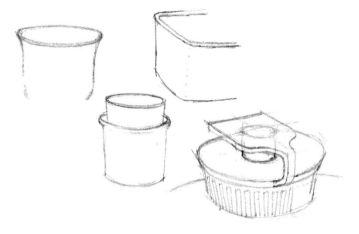

project

1 Set up a piece of bold, striped or patterned cloth and put it in the path of a direct light source like a table lamp. Arrange it so that the stripes or patterns go across the folds and make at least two drawings of it, one with and one without tone. Make some more drawings using different tools and media.

2 Set a group of objects, including some which involve ellipses, against the light from a window. Make this drawing using a combination of at least two tools (say a 6B pencil and a water-soluble one). Watch for reflected light and tonal relationships with the surroundings. Take care with the shapes of shadows.

3 Make a drawing using several tools and media of a subject which is not a still-life, but where there is strong light. Think of everything as shapes and choose your tools carefully.

4 Draw a corner of a room where the light is interesting.

5 Make a self-portrait, however inexpert at this stage. If you are wearing a very light top, notice how light is reflected on to the chin area.

7 flowers and natural forms

Water-soluble pencil and graphite pencil. Both drawings show the double spiral construction of an artichoke.

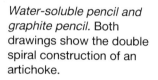

STRUCTURE

In order to draw natural forms well, it is essential to understand how things grow and how their 'limbs' join the main body – an analogy that will make it possible to relate to human structure when we get to it.

The structure of some natural forms is particularly interesting. Try to get hold of a giant sunflower head, a pine cone, a pineapple, a thistle, globe artichoke or teasel and study them carefully. They are all of double spiral construction. This should help you draw them; don't just guess where the lobes, petals or seeds are.

Look at how the seeds of the sunflower are arranged in criss-cross curves, how the pointy bits on the pineapple curve in a spiral both ways as well as up and down, and how the same sort of construction can be seen in all the others.

The more you investigate things, the more exciting they become. Some shells have a three-dimensional spiral, diminishing in size at one end, with others it is a sort of unravelling roll. Don't forget that creatures once lived in these shells and that has determined their structure.

A pineapple is very difficult to draw but it's worth trying. Notice how the spiky leaves grow out of the end and how each leaf folds round the previous one. Don't fall back into the trap of drawing the outline; put in the construction lines carefully and remember that the internal form affects the outer. Notice how the small squarish forms on the pineapple follow the main form, and appear narrower and less square as they turn away from you.

With this sort of detailed drawing it is useful to put in the direction lines first.

RIGHT Hege Jensen (student). *Pastel.* This sheet of studies with colour notes showing details of a pineapple would be useful for future reference.

tip

When you have finished drawing your pineapple and are ready to cut it up for eating, don't throw the leafy top away. Let it dry naturally and it will curl up and go brown and spiky. Instead of saying, 'How ugly,' look at it as another superb drawing subject. Left in a cupboard, sometimes it will not only last for years but will actually **start growing** again!

Surface decoration
This should present few difficulties now that you have practised drawing folds and patterned cups. The patterns on a shell present the same problems, so remember that they follow the form and diminish as the shell turns away, like the squares of the pineapple. If you draw the patterns or marks as if they were on a flat surface, it will flatten out the whole form. So do explore your subject thoroughly before you start to draw.

tip

Hold your shell, or whatever, in the palm of your hand and shut your eyes. Visualize it, not by looking at it but by feeling – it will help you to understand the form better. After that you could look at it carefully, then shut your eyes and visualize again. This exercise trains your eye and aids your ability to remember what you see.

Stalks, stems and joins
Many beginners, for some unknown reason, leave gaps where branches join a tree trunk, as illustrated here. This may be simply because they don't look properly and they leave out what they don't see. As this won't apply to any of you, there'll be no gaps! Stalks, stems, trunks and branches all join in ways particular to the type of plant, so look for growth characteristics and never forget that even thin stems and branches have form just like main stems and trunks. All sorts of joins – even teapot handles – present a similar problem.

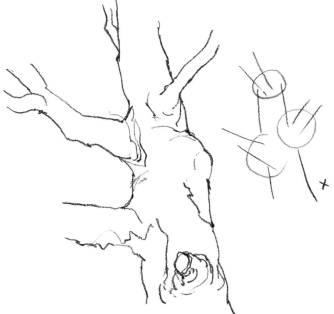

ABOVE This illustrates how the branches of a tree join the trunk (left). The diagram on the right illustrates a beginner's lack of observation.

Broad-nibbed pen.

Different views of flower
pod showing central
alignment.

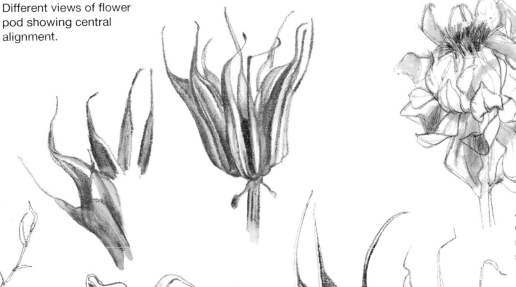

ABOVE Sometimes a small
drawing done in a
notebook will clarify the
structure of a plant.

Centres and curls

Another common error is the placing of a flower head
out of alignment with the stalk. If the stalk is clear of
overlapping leaves, this is due to a lack of observa-
tion. If there are leaves or petals obscuring the join,
people who draw only what they see, without under-
standing structure, are likely to be at fault; they for-
get that just because we can't see something, it
doesn't mean that it isn't there.

'Following through' will solve this problem. Think
back to the way the eye can be led. Any line, straight
or curved, even if interrupted, can draw the eye in
the direction it should go. Continue the lines of a
stalk lightly so that when you come to draw the
flower head, it will be structurally sound. Trumpet-
headed flowers show their growth pattern clearly, as
do flowers seen sideways and clear of leaves, but all
stems must appear to grow from the centre of a
flower head. The same principle of following
through can be seen in the curls and twists of a leaf:
each has its own characteristic curl or crinkle.

Leaf veins

I find that nearly all beginners draw leaf veins as
black (pencil) lines (sometimes not joining the minor
ones to the major ones, as with stems and stalks),
even though some veins are lighter than the leaf and
some are heavily indented. It is probably a hang-over
from childhood – a lot of small problems stem from
our conditioning, so try to be aware of this.

If we are using monochrome or limited colour, leaf
veins raise the issue we have looked at before:
whether to use tone or not, and if so, whether to use
it for colour or for light and shade.

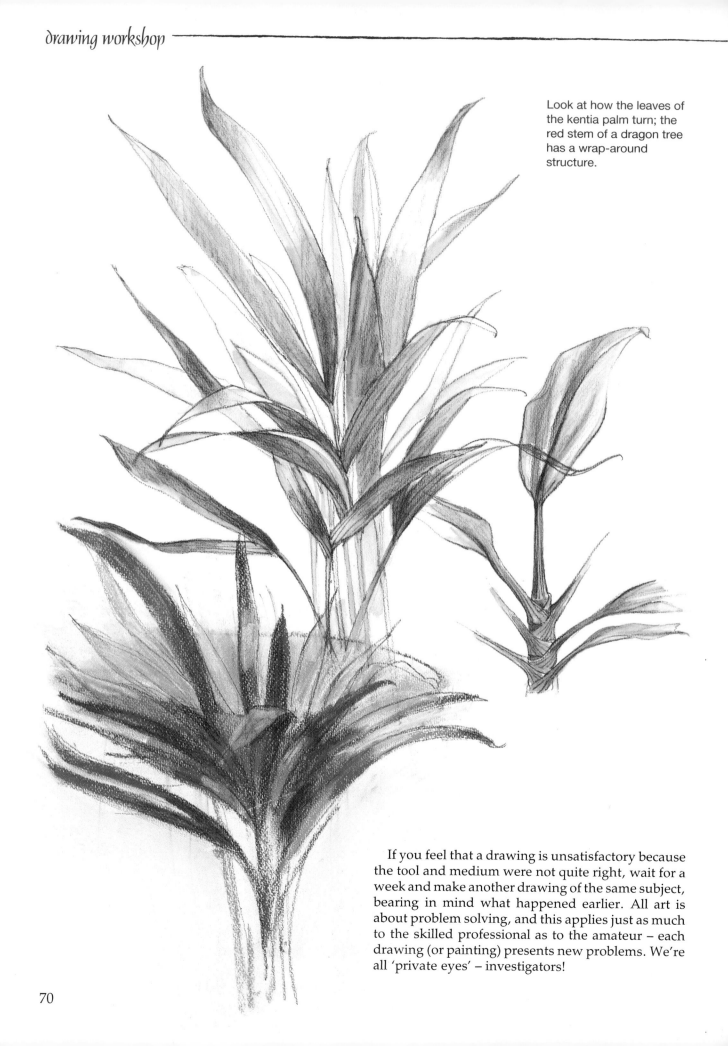

Look at how the leaves of
the kentia palm turn; the
red stem of a dragon tree
has a wrap-around
structure.

If you feel that a drawing is unsatisfactory because
the tool and medium were not quite right, wait for a
week and make another drawing of the same subject,
bearing in mind what happened earlier. All art is
about problem solving, and this applies just as much
to the skilled professional as to the amateur – each
drawing (or painting) presents new problems. We're
all 'private eyes' – investigators!

Conté pencil. Even thin stems are drawn with double lines where possible to show thickness.

Coping with mass

If you are drawing something like a hydrangea head, which is made up of a mass of tiny florets, you have to decide whether to draw each one in the same amount of detail and the same tone, or whether to draw the nearest florets darker and in more detail than the rest. Or is there any other way of solving this problem? In painting it is easier to suggest such things by using thinner or paler colour; something close to this effect is possible with drawing tools if you think about it carefully. You are probably well into the process of drawing by now and should be able to solve such problems without clues from me.

Pen and wash. Even in a loose, unfinished drawing, the thickness of stems and the way leaves join and turn should be indicated.

PERSPECTIVE OF NATURAL FORMS

We have already begun to deal with this, although not in any detail, in thinking about how the small forms on a pineapple and the patterns on a shell diminish as they recede.

While we expect to have to learn something about perspective when we draw streets and so on, very few of us realize that perspective also applies to plants. Think of a plate and then think of the head of a giant sunflower. Can you see that, viewed from the side, they are like a wheel in perspective? Leaves, however small, will follow the rules of recession, and plants climbing a wall will follow the perspective of that wall.

Look at the drawings and diagrams here and then find similar subjects and try to solve the problems on your own. Choose plants or other natural forms where the perspective is easily seen, and make drawings of them. At the moment it is enough to accept that there is perspective and to try to see it for yourself rather than worrying about the theory. The next chapter will extend your knowledge of perspective so that you can apply it gradually.

Circular flower heads, like wheels, are based on an ellipse.

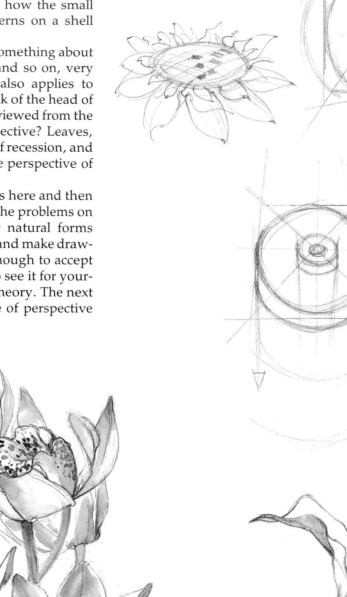

Coloured pencil and watercolour.

This leaf shows perspective and how the stalk follows through.

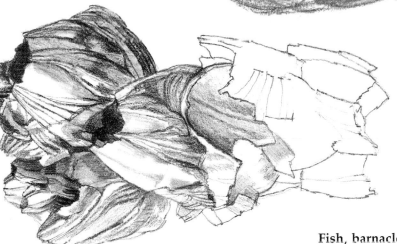

ABOVE *Graphite pencil and pastel pencil;*
LEFT *Graphite pencil with coloured pencil;*
BELOW *Coloured pencil.*
Examples of how an optical illusion can confuse convex and concave forms.

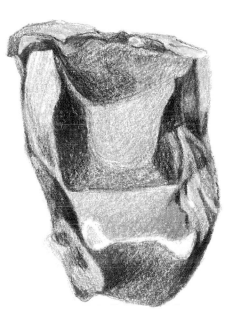

Fish, barnacles, bones and stones

The basic problems of structure and perspective are the same for these subjects as for any other. The reason for listing them here is to remind people that there is a host of subjects that may not be as pretty as flowers and shells but which are just as fascinating to draw.

If you are not a vegetarian, why not draw a chop bone, or a fish before you cut its head off? Or you could look for dead crabs or claws or other things that get washed up on beaches. Stones and pebbles can be quite spectacular in their form and colour.

Dead and crumpled leaves, discarded husks, dead flower heads or dried seaweed are all good things to investigate in your efforts to learn to draw well. I have several tall glass jars filled with small dried things and small baskets with less fragile ones, so there is always something for me to draw when I am stuck, and they are nice to look at anyway. Why not start a collection of natural forms – it could become a new hobby?

73

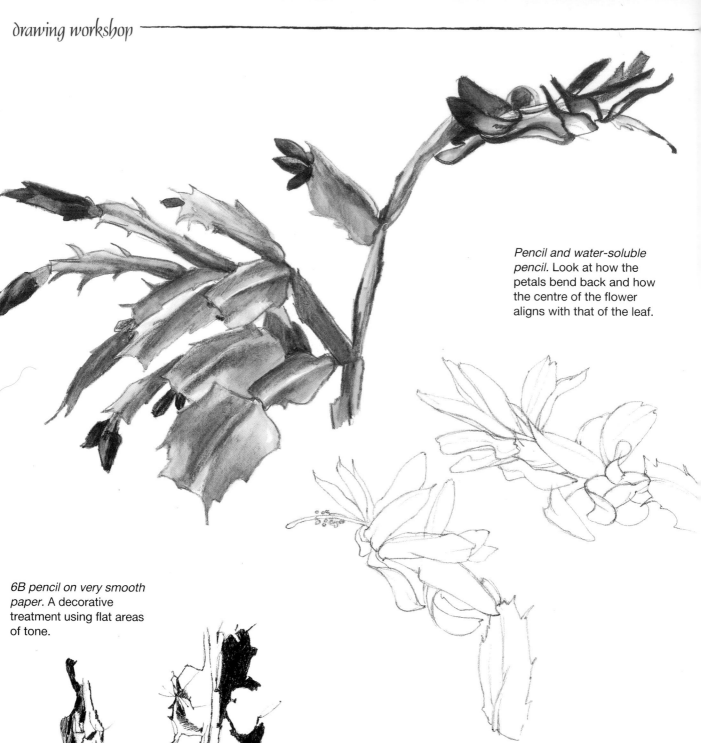

Pencil and water-soluble pencil. Look at how the petals bend back and how the centre of the flower aligns with that of the leaf.

6B pencil on very smooth paper. A decorative treatment using flat areas of tone.

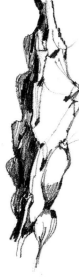

TONE AND COLOUR

Many people are too heavy-handed in their use of tone and colour when drawing natural forms. Strength is good in drawing, but when strength becomes solid, clumsy or heavy, it destroys the quality of the living object, especially in the case of flowers. Pale, thin drawings are almost equally unsatisfactory, so aim at sensitivity and delicacy where the subject demands it, but make sure your draughtsmanship is firm and not vague or characterless. A tall order, but one well worth considering carefully.

74

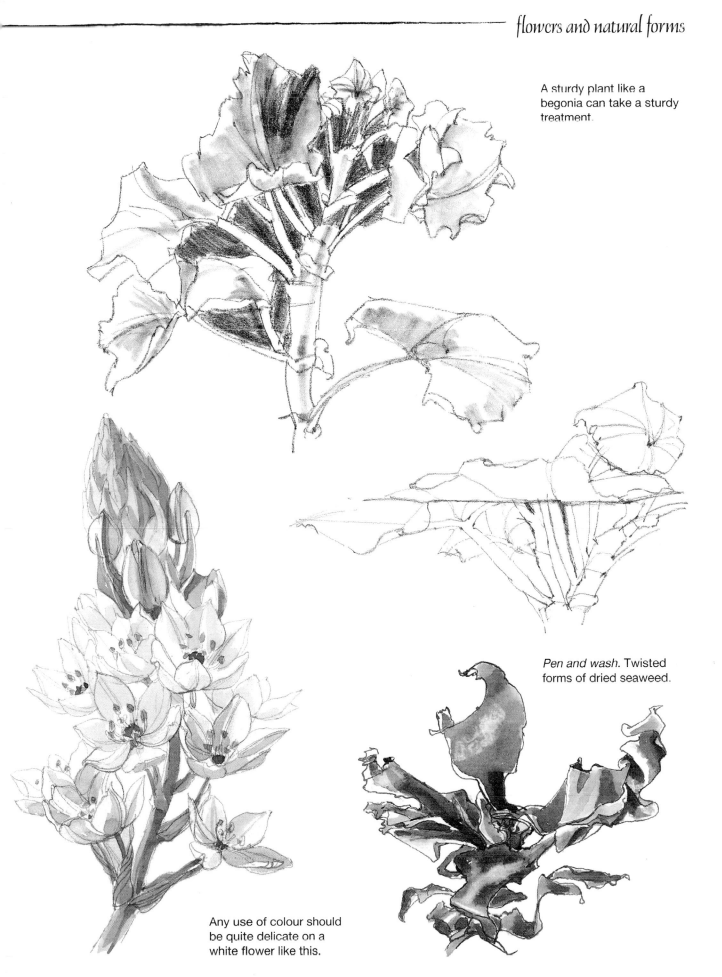

A sturdy plant like a begonia can take a sturdy treatment.

Pen and wash. Twisted forms of dried seaweed.

Any use of colour should be quite delicate on a white flower like this.

LEFT *Pencil.* Study of both halves of a pepper.
TOP *Pen.* Textures are used to fill areas and to give a flat, decorative treatment.
ABOVE Another decorative treatment using solid areas of ink.

DECORATIVE TREATMENTS

So far most of the teaching in this book has been based on the assumption that most readers will work through it as if it were a course, and will be making study drawings that are fairly straightforward, with a 'realistic' bias. Natural forms offer a particularly good opportunity to experiment with more decorative treatments – perhaps because the subjects tend to be more decorative and therefore lend themselves to simplification.

Try making a straight study drawing first and then one where the shape is dominant, without any treat-

ment to show form. In other words, use lines and devices that interpret form in a more stylized way. Any tone or colour you apply should be kept flat and any increase or decrease in density should be smooth. Look at the drawings here, then find a different subject of your own to experiment with.

Naturalism is not the only style of drawing, but deviations from it should not be made until you can draw well and also understand why you are making changes. There are people who latch on to different styles and techniques in the mistaken idea that they are 'modern' or 'daring' or will attract attention. Don't fall into that trap, just be yourself.

Keep an eye on your greengrocer's shop and watch the changes through the season; you may find interesting things to draw, even if you don't want to eat them. A piece of root ginger, for instance, presents a lovely convoluted form; cutting and peeling vegetables and fruit can also reveal hidden visual treasure.

If you develop your visual curiosity, the world around you will look quite different – even watching television for entertainment can reveal aspects which were missed before because of a lack of visual awareness. Ultimately you will find yourself seeing more wherever you are. *To learn to draw is to learn to see, and not the other way round.*

BELOW *Water-soluble pencil.* A naturalistic interpretation with more emphasis on decorative qualities.
BOTTOM *Pencil.* Although the seeds appear random because of the way the fruit has been peeled, the line of seeds to the right shows the pomegranate's structural pattern.

project

1 Make six drawings of a natural form that interests you out of curiosity rather than liking.

2 Take two different viewpoints of a natural form and make a straight drawing of each, one with dry colour (for instance pastel pencils or coloured pencils) and the other with water-soluble pencils. Then make a decorative treatment of both with any tools. Try to make at least one of the drawings without using line to show form.

If you can't afford a lot of tools, the colour you use does not need to be the same as that of the subject (just be careful of tonal relationships), so your original minimal stock of colours will do.

8 towns and buildings

Probably more people live in towns or suburbs than in the country, yet almost all amateur artists say they want to paint landscape. For town dwellers, this may mean driving for an hour or two, or humping equipment on buses and trains and then walking some distance. Whether you live in a town or in the country, landscape can present other practical problems: the wife or husband whose partner doesn't like sitting around while the other draws, or the family holiday when it is difficult to go off on your own and even producing a small notebook attracts attention or comment. Then there's the weather, which can change very quickly, and so on.

If getting to the country is difficult, why not draw your own town environment? When you explore with an open, enquiring mind, you will find lots of things which you may not have noticed on your daily round.

To enable you to draw streets and buildings effectively, we need to deal with the issue of perspective. You have already struggled with the perspective of still-life objects, and begun to see that of natural forms. Now is the time to get to grips with it, because people, land, sea and skies all have perspective, as we shall see in later chapters. Try to regard it as an interesting puzzle, like a crossword or a chess game!

John Blockley, 'Staithes'.
Pencil and coloured pencils.

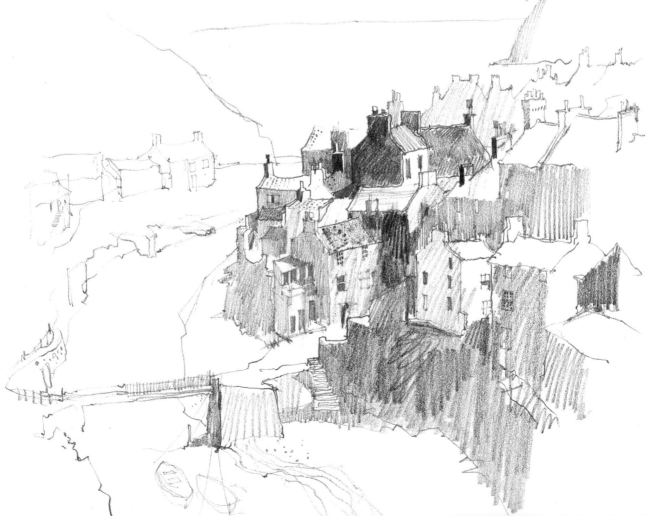

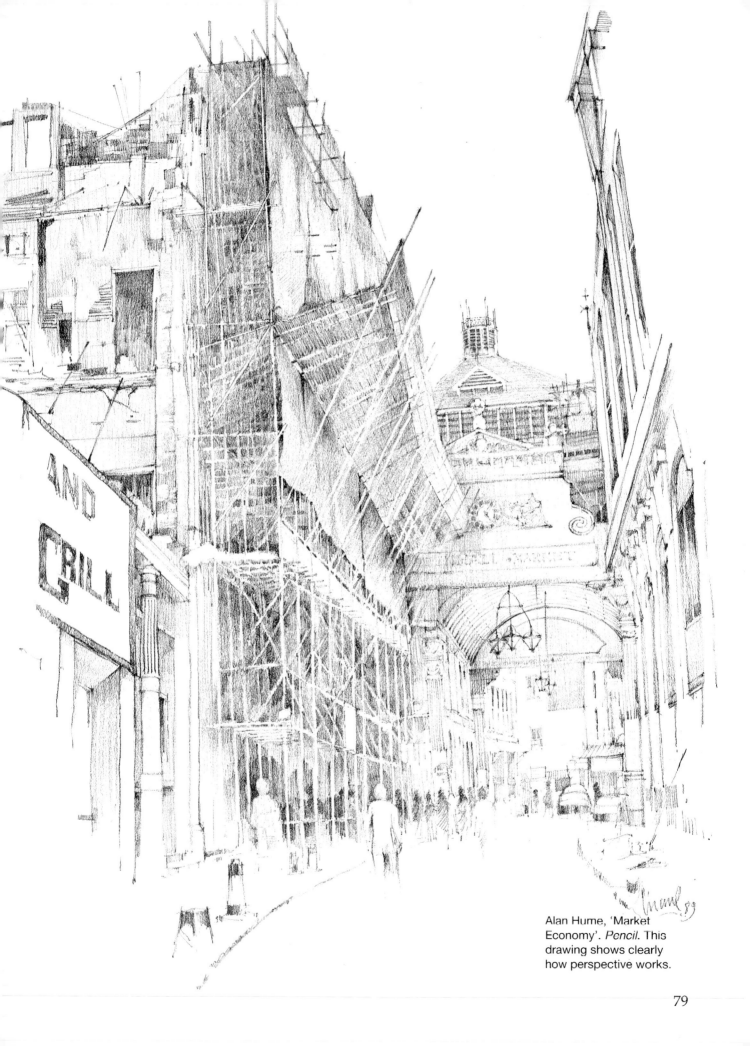

Alan Hume, 'Market Economy'. *Pencil*. This drawing shows clearly how perspective works.

79

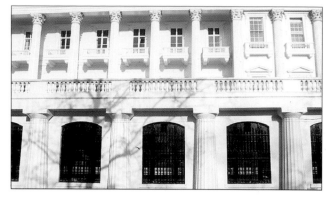

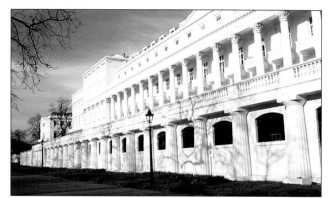

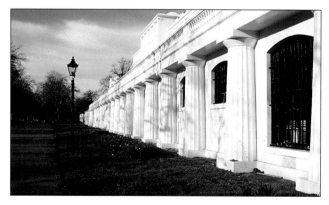

LINEAR PERSPECTIVE

Perspective in art is the name given to a method of creating an illusion of three dimensions on a two-dimensional surface. Some artists prefer to 'flatten' their subject-matter to reflect the flat surface on which they draw or paint. Others compromise by suggesting perspective through colour, space, or their personal interpretation of their subject. However, in order to understand how to break rules, we must first understand the rules themselves.

In Chapter 6 we touched on the fact that lines appear to get closer together as they recede, and appear to meet at a point on the horizon known as the vanishing point. This is one of the basics of perspective, but putting this knowledge into practice is often complicated and many beginners find it daunting, especially in the case of gentle slopes where the vanishing point is outside their 'frame'.

First of all, remember that wherever you are, the horizon will be a straight horizontal line on a level with your eyes. So if you stand, it is at one level; if you sit, it is at another; if you look up, it is high; if you look down, it is lower. Next time you are waiting for a

ABOVE LEFT Ian Ribbons, 'Lloyds Building'. *Watercolour*. Even when the style of a drawing is loose and free, the structure must still show.

ABOVE Three views of Cumberland Terrace, London, showing how the perspective changes.

bus, try looking straight ahead and from side to side, keeping your eyes level. Notice which points on a building coincide with your eye level. Then look up and notice how the sides of any tall building appear to lean inwards as they recede. There is no need to try to fix the exact spot where lines would appear to meet, even if it is within the frame of your picture. You will soon be able to estimate the angles of receding lines by eye.

Doors

Stand with a door open towards you, about 2 m (6½ ft) from the near edge. Look at the top and the bottom of the door. See how the line from the nearest top corner appears to go downwards as it moves away from you and the bottom appears to slant upwards.

To make sure you understand this, point at where the nearest top corner appears to be and follow the top of the door with your finger. Your arm will move downwards. Do the same with the bottom edge and your arm will move upwards. Then get someone to shut the door very slowly while you watch what happens to these lines.

Now do the same thing with a door opening away from you. Did you think about where your eye level was? Make the same experiments sitting on the floor; notice where your eye level is now in relation to the door and how the top line slopes down more steeply and the bottom one is shallower.

Remember that *lines which start from a point above your eye level will appear to slope downwards as they recede, and lines which begin from a point below your eye level will appear to move upwards.*

When you are quite clear about all this, make some drawings of open doors and what you can see of the rooms beyond. If you set a chair at an angle to the door and draw that, you will find that the lines converge and 'vanish' at different places on your eye level.

Since this chapter splits into several sections, do the first project to put what you have learned so far into practice.

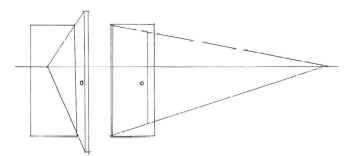

Perspective of doors
opening in both directions.

BELOW Ian Simpson,
'Hungerford Railway
Bridge'. *Pen and wash.*
Look at the level of the
tops of the pillars and the
point where they enter the
water. The curved window
on the left is also well
worth studying.

project

Find a place which contains some of the things you have been looking at or drawing: an open door, chairs, tables, perhaps a paper bin, a rug, a bench. It could be a corner of a garden patio with furniture, or a work shed – anywhere which is interesting and has some effective lighting.

Choose the tools you enjoy working with most there's no point in struggling with too many problems at one time. If there is strong light, look carefully at the shadows – their shape, tone and colour – and notice how they relate to each other and to the various objects. Remember that shadows are attached to the object casting them and that they bend and change shape depending on where they fall; they also have perspective.

WHEELS, ARCHES AND ROOFS

One of the problems we have not yet considered is how to tackle the sort of curves, points and ellipses seen in townscapes: pointed roofs, arches and wheels. To draw a wheel think of a flat ellipse and one standing on its side. If the thought of drawing the ellipse of a wheel seems more difficult than drawing the top of a cup, try putting your straight-sided mug on its side and draw the top. Now imagine that this ellipse is a wheel in perspective: how do you put the hub in the right place? Don't forget that wheels have thickness; their structure is basically two parallel ellipses, each with thickness. 'Following through' will help you draw them.

How do you draw a pointed roof in perspective, and how do you find out where to put the apex of a curved archway? The point of the roof or the apex of the curve will appear to be off-centre on the far side. If you look at the diagrams on this page you will see that the method of finding the central point is similar to that for finding the centre of a wheel.

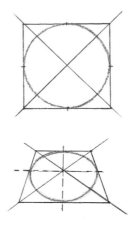

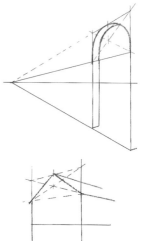

A circle fits into a square, so to find its centre simply draw diagonals from the corners of the square. The centre of a circle seen in perspective will appear farther away, since space contracts as it recedes.

Construction lines of a curved arch and a gable roof in perspective.

Alan Hume, 'Me Dad's Handcart'. *Pencil.* A good example of wheels drawn in perspective.

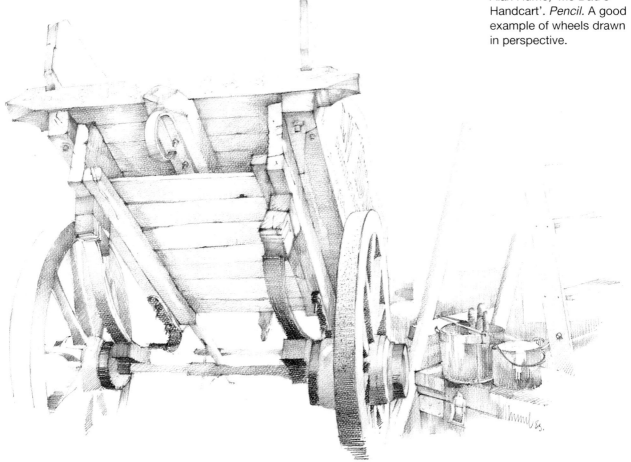

Although the buildings are of different heights and designs, the effect of perspective on the gabled roofs can be seen clearly.

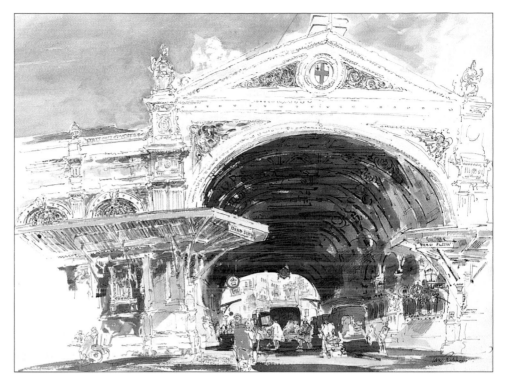

Ian Ribbons, 'Smithfield'. *Pen and wash.* Even in this free drawing the theory of arch construction can be seen.

PERSPECTIVE IN PRACTICE

Let's go for a walk. Take with you a notebook with good cartridge paper, about A4 or A5 size; a soft pencil, a knife for sharpening it and an eraser; a ballpoint or fountain pen and a dry colour pencil. Also take your small L shapes and clips. Find an interesting spot where you don't feel too conspicuous – a street corner, a secluded position in a market, a corner of a café or pub – and select an area with your viewfinder; fit your L shapes together to make a frame about 2.5×4 cm (1×1½ in). Now make a basic drawing (omitting the details) of your chosen composition.

When you feel you have established the bare bones of the scene, look at any people or things standing near something you can use as a reference point. Take your coloured pencil and mark in the position of their feet and the top of their head. Don't draw, just make marks and lines. Note, in writing, who or what the marks represent.

Draw the scene again on another page of your notebook (or use a tracing paper overlay) and repeat the exercise, adding marks as more people, children, dogs, cats and cars appear. This way you will learn your perspective by personal observation and practical comparisons, which will be more useful when you come to draw such scenes in greater detail than if you only look at other people's diagrams. If you start to draw without these preliminary studies, the basics of perspective will get lost.

Here the heads are roughly level, whereas the position of people's feet reflect their distance from the camera.

Don't forget to note the relative heights of people and buildings to things like telegraph poles or street lamps. Compare the tops and bottoms of cars to coaches, coaches to vans, adults to children of different ages, and so on. How do these relationships change when the subjects are farther away? Note the slope of walls and doors or windows as they recede.

In other words, look not only at the 'contents' of a street but also at how the position of things in space determines their relative size. Soon you will find you can visualize these things without having them in front of you.

Books can help you with perspective, but they do not show you how to judge with your own eyes. Once you have trained your eye, that is the time to read some more theory and set it against your own observation: it will then make more sense.

Different viewpoints
When you have gone as far as you can with your first set of comparisons, make a new key drawing of the same place from a different viewpoint. Stand up or sit down, depending on what you were doing before. Make similar comparisons and see what happens when your eye level is high, low or in between. Looking down from a multistorey car park is a good way of getting a high viewpoint.

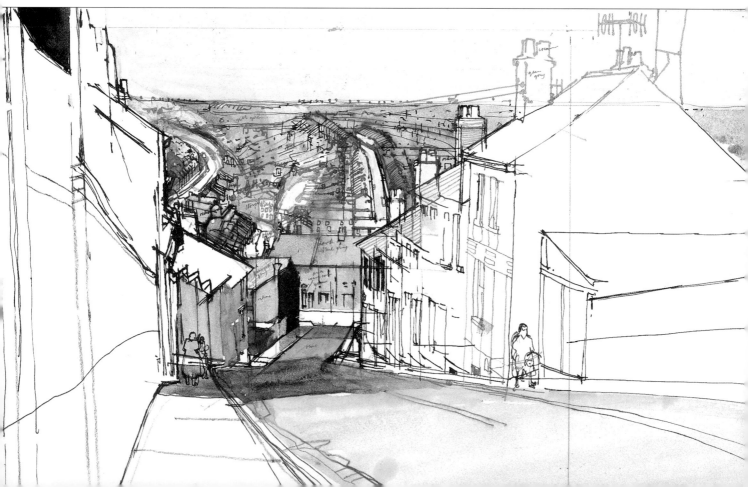

OPPOSITE Rooftops make an almost geometric pattern.

Ian Simpson, 'Camden Road Station'. *Ink, charcoal pencil and wash with white Conté.* When the direction of a building changes, the perspective will too.

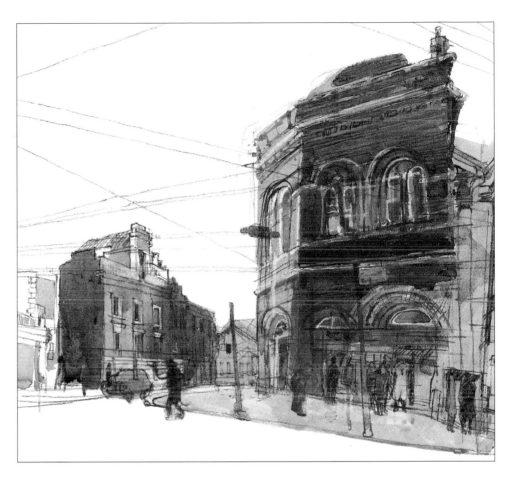

OPPOSITE BELOW Ian Simpson, 'The Steep Hill'. *Pencil, pen and wash.* Study how the high viewpoint affects the perspective lines.

When you get home, sort out all your findings so that you can use them later as reference material. This will help you learn to use your notebooks as the backbone of your work. A really good notebook (as we'll see later) can supply you with enough work to keep you going for months without having any subject in front of you.

Ian Ribbons, 'Tower Bridge, London'. *Pen and watercolour wash.* The free treatment of clouds and people adds vitality to this drawing.

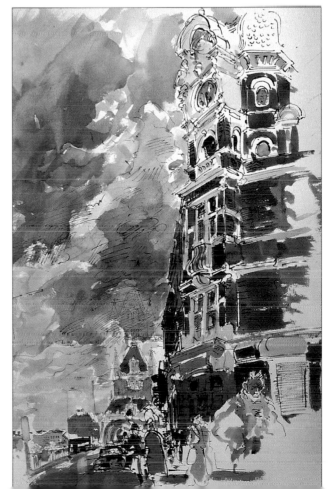

project

Now that you have ventured outside to apply your knowledge, try a serious drawing of a car or other vehicle in a street setting. Pick an interesting angle to draw from and strong lighting. I know that a lot of people prefer natural to mechanical subjects, but at the moment we are not dealing with what we 'like' but with what is most useful for practising certain problems.

BUILDINGS

Buildings can be marvellous to draw, although they test your grasp of perspective. I like the feeling of old buildings with their porches, pillars and carvings, and the beautiful sky-reflecting glass and interrelating rectangles of modern ones.

Don't choose a building and start trying to draw it straight away. Put your notebook and tools in your bag and go for an observation walk. Find a tall modern building and just look at it. If you like it, good. If you don't, you are just looking and learning. Make a clear note in your head of the angle of the roof. Look half-way down and note the direction of the lines of the windows. Look straight ahead at eye level and then down to ground level. Now shut your eyes and try to visualize it exactly. Keep on doing this until you feel your visual memory is improving.

Move to an older building and do the same thing, then return to the first one and remind yourself of levels and proportions. Finally, take a second look at the old building.

Now go and have a coffee and make notes in your book. Try drawing the main shapes and proportions

Compare these old and new styles of architecture.

of each building. You will soon realize which bits you forgot to look at sufficiently well. When you feel refreshed go and check your drawing against the real thing and make corrections or adjustments. In each case, put in just a line to show the height of a figure to indicate scale.

Next time you go out, make a small drawing, on the spot, of one of the two buildings. Try to draw both, the second fairly soon after the first, so that your knowledge of each grows at a similar pace. When you have done as much as possible with these subjects, repeat the exercise with two domestic buildings rather than public ones.

Try to exhaust all the possibilities of this sort of observation and begin to draw all your findings. Make separate notes about light direction or mood if you can't cope with it all on the spot at one sitting.

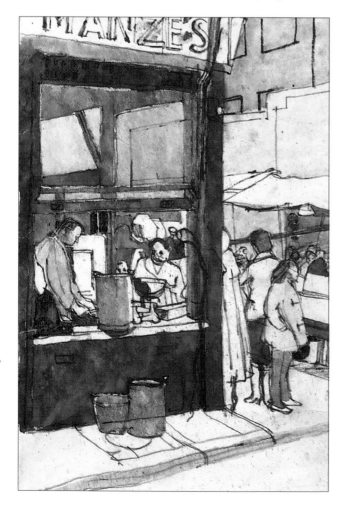

Ian Simpson, 'Manze's'.
Charcoal pencil and wash.
A good illustration of the relationship between the height of people and their surroundings.

Receding spaces

Just as all lines converge as they recede, so do spaces. Look at balustrades, railway sleepers, fences and railings; notice how the intervals between the bars or struts diminish with distance until the struts seem to become almost solid.

As for steps, if you observe carefully, apply the basic rules of recession and make sure that the stair treads are limited by the general construction lines, you will soon be able to cope. Looking at these photographs should help.

I am deliberately not going into too much theory about perspective, as I have found that it can be confusing – and unhelpful. I once had a class of thirteen-year-olds who clamoured for a lesson on perspective, even though we'd been looking at street scenes as this chapter has suggested. They had seen for themselves, but they were still convinced that 'real' perspective should be learnt through theory. They were so insistent that I did devote a lesson to vanishing points and receding lines. They made diagram after diagram and thought it all looked very professional. I then set them a railway station scene to paint and gave them the week between lessons so that they could look at the local station.

They painted their pictures, convinced they'd got all their vanishing points right. In fact the theory *was* correct, but the pictures were quite hilarious; even the trains vanished to a point! They hadn't looked properly at the real thing.

The following week they returned to their work with fresh eyes and were shocked by the absurdity of what they had drawn. Then they began to laugh – and asked if they could tear up their work. After that they looked and applied the rules intelligently.

Very few of us ever gets perspective dead right, but looking intelligently and working it out for yourself will give you better results than following theory without understanding how to apply it.

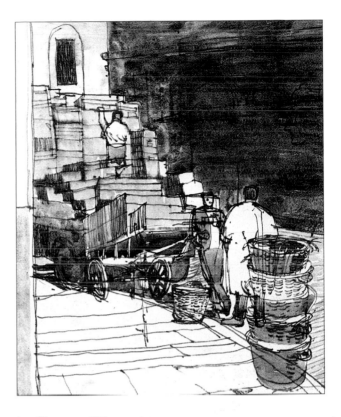

Ian Simpson, Billingsgate Fish Market. *Pen and wash.* Some of the lines of objects can be seen through the superimposed figures – a good way to get relationships right when making a working drawing.

BELOW LEFT These palings show how spaces recede with distance.

BELOW Notice how the corners of the treads are in line with the direction of the rise.

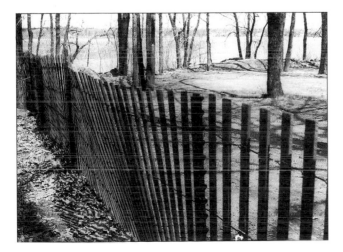

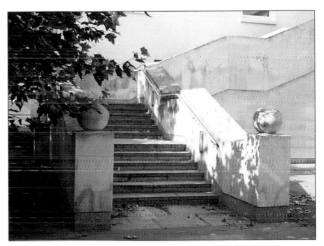

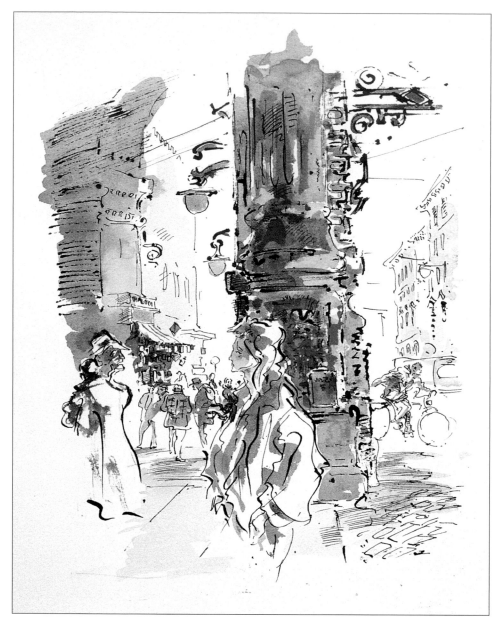

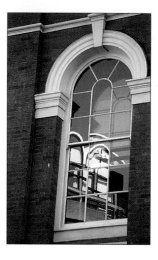

ABOVE How would you treat these two architectural details in a drawing?

Ian Ribbons, 'Bologna, Italy'. *Pen and wash.*

What to leave out

When beginners draw buildings they often don't realize that windows and doors have both depth and thickness, and that there are a multitude of different designs: there are mouldings and recesses, rebates, sills, catches, sashes and casements, plain and mullioned windows; doors can be arched and deep, shallow and fanlighted, columned and architraved. So it is not enough to draw rectangles. Each door and window has its own character and fits the building – or not, in the case of 'replacement' windows put into older houses.

But how much architectural detail should you put in? When you are making a working drawing for future reference, or a study drawing, you should put in as much as you can, making a separate drawing of

a detail on the side, or on another page, if necessary. For general drawing, include just enough so that the viewer can appreciate the style of door or window and the character of the building. Never leave the viewer in doubt as to what you are trying to show, but work out your own shorthand: leaving the right things out is a skilled job!

7 7

towns and buildings

STRUCTURING YOUR COMPOSITION

Refer back to the chapter on composition if necessary, and ask yourself questions like these to clarify your objectives when drawing street scenes:

What is the most interesting feature in my chosen portion of this composition, and where shall I put it in the frame?

Is there something large and interesting in the foreground which would dominate and enhance it?

Would it be a good idea to look through something in order to lead the eye to the main area or focal point?

Do I want the buildings to dominate, or the street itself, or would a close-up group of people or some street furniture set the scene back comfortably? If so, just how much should I include?

Is there any street furniture or parts of vehicles which could be exciting focal points in themselves and still give me space to practise my knowledge of linear perspective?

Pavements are always worth a close look – we usually take them too much for granted.

BELOW Raymond Spurrier, 'Rethymnon, Crete'. *Pencil.* A composition structured around foreground interest.

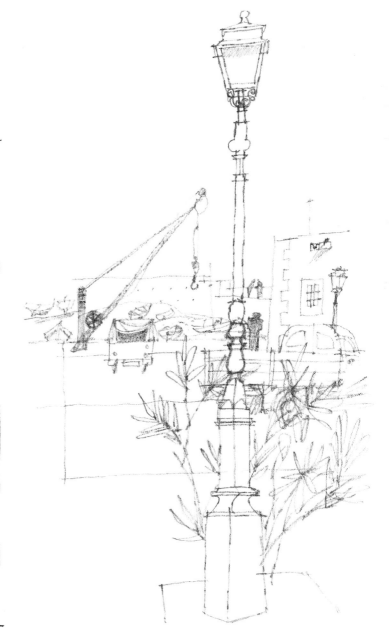

project

1 Just for once, turn to photographs, not to copy, but to check your understanding of perspective.

Find a large photograph of complicated buildings, preferably with people, traffic and perhaps animals as well. Now get some tracing paper, a ruler and a very soft pencil (so that you won't have to press hard). Identify the eye level – it may not be visible as a line, but it will be the horizontal to which other lines incline. Trace this line, then draw the direction lines of everything, and mark the relative positions of people's heads and feet. Do this to as many photographs as you feel is necessary to make sure you understand. When you do, you can throw away the diagrams!

2 Find a good place to sit and make a straight study drawing of a street scene, including the shapes of any people or cars. Don't draw these in detail, but the shapes should correspond to what you see: don't just put in oblongs or stick figures! When you get home, put your tracing paper over your drawing and check the perspective, as described above. If it's not right, don't worry, you just need to practise more.

3 Make a drawing using colour as well as black and white of a building site or builders' yard. The perspective here will be less obvious than in a street but there is likely to be a lot of texture to make things interesting. In addition, your skills at composing will be called into play in deciding where your main interest lies.

89

9 landscape

Landscape need not be just a seasonal subject, as any time of year can be good for making informative drawings which can then be developed indoors. Many professional artists work this way; being away from the subject and the distractions of an audience means that there is more time to think in depth about their approach and method. Even if you prefer to work directly out of doors, these things should not be forgotten in your eagerness to begin.

As with any subject, it is not enough to say, 'I like a landscape'; you must know why you like it. This will help you select a viewpoint and composition. Landscapes vary so much, but there are always some aspects that are more interesting than others and it is up to you to decide which they are, and to make your drawing show this.

Jean Vaudeau, 'Golden Cap'. *Chalk.* It is not always necessary to draw landscape in full colour: this drawing is almost monochrome and only the touches of yellow and cream reflect the title.

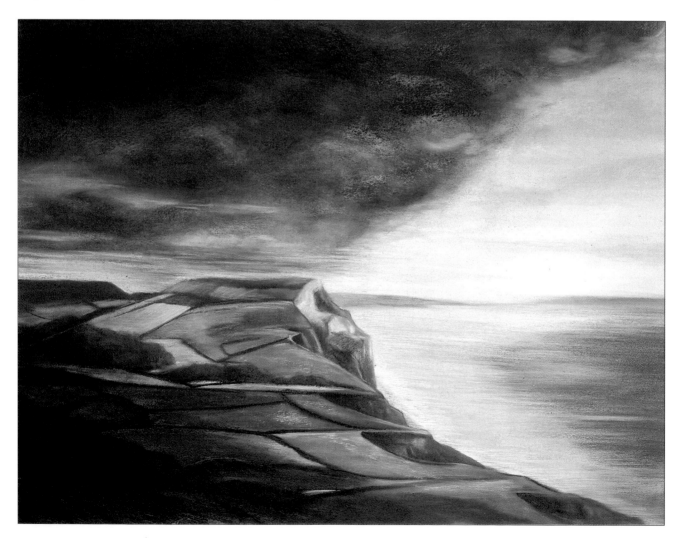

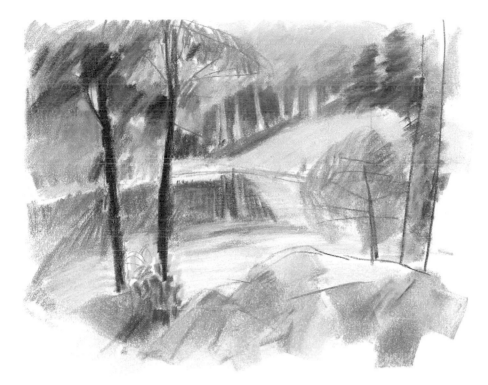

Pastel. Working drawing of Pinks Lake, Canada.

LAND FORMATIONS

In a car or a train, or when you are walking, observe the landscape carefully, rather than casually. Out-crops of rock, scree-covered slopes, flat wheatlands or marshland are the result of geological formations; understanding the structure of the land will prevent common visual clichés of 'rolling hills' looking like humps and lush trees set illogically in stony areas.

Notice how the ground changes from field to field, shape to shape, crop to crop, texture to texture and try to see your subject in visual terms rather than in words, which can be inhibiting. For instance, if you feel your drawings of buildings are not yet up to the standard you hoped for, when you come to draw landscape with a building in it, labelling it as such can cause problems. You may assume that the building is more difficult than anything else and draw every-thing less well as a result, because you have under-estimated other difficulties, lost confidence and been cursory in your observation.

Broad pen with Indian ink.

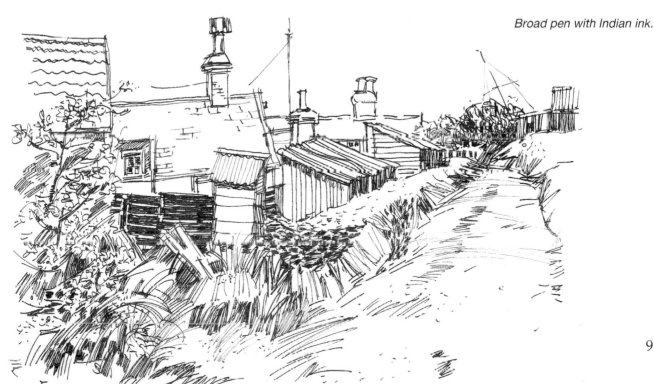

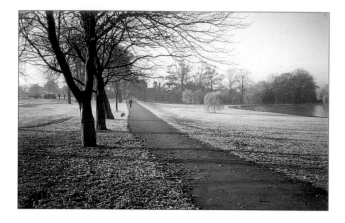

TIME OF DAY AND WEATHER

The main challenges in drawing landscape are the movement of light and changes in the weather. Many people wait for a pleasant sunny day in order to sit outside in comfort and they start to draw as soon as they've worked out their composition – or they don't even bother to do that! No doubt by now you will have realized why this approach is unwise, and setting out to 'copy' what is in front of you not only produces boring pictures but invites disaster. What if the light changes, or the trees have changed colour, the hills have disappeared in mist, the fore-ground has gone dark, the shadows are different? The living is alive!

You will probably have noticed that plants also move while you're drawing them. They sway in the wind, begin to droop, flowers may open or shut, or turn, almost imperceptibly, towards the light. The way to get used to your subject moving is to train your visual memory and to observe changes in your surroundings so that you learn how to adapt your drawing to them.

It is a good idea not to work at mid-day when the sun is high and strong. This makes the contrasts very sharp and the shadows will be short. The strength of the light may be what you want to convey in that par-ticular drawing, but longer shadows will give greater interest. Earlier or later in the day are good times for drawing and painting.

Weather, of course, can make things very exciting. Heavy storm clouds create dramatic light effects, early morning mists produce a beautiful range of soft, close tones, low evening light gives lovely contre-jour effects. Don't forget to squint to simplify areas of tone.

All open-air subjects benefit from being seen in in-teresting lighting and seasonal conditions, so be choosy if you can and be stalwart in facing adverse weather. Working in the snow gives lots of oppor-tunities for using white paper space with rich blues and browns or velvety blacks in pencils or pastels.

When there are heavy thunder clouds about, study the sky even if the conditions prevent you from drawing. Always carry your small notebook and a pen or pencil so that you can make quick notes – even written ones will do. You are in the process of train-ing your visual memory, so *any* kind of note-taking will help this. Use the trick of shutting your eyes and remembering what you have seen.

ABOVE The colour of frost is delicate yet definite. The mist creates subtle tonal changes, while the sunlight and shadows suggest crispness.
LEFT Notice the colour, texture and length of these shadows.
BELOW Muted colour, layers of tone and not much detail in the distance are typical of hazy weather.

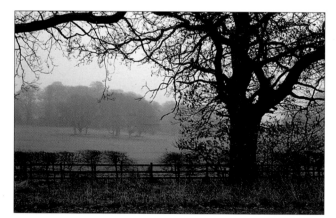

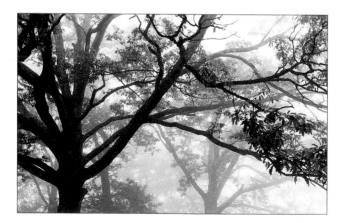

LEFT Here tonal changes suggest spatial perspective.

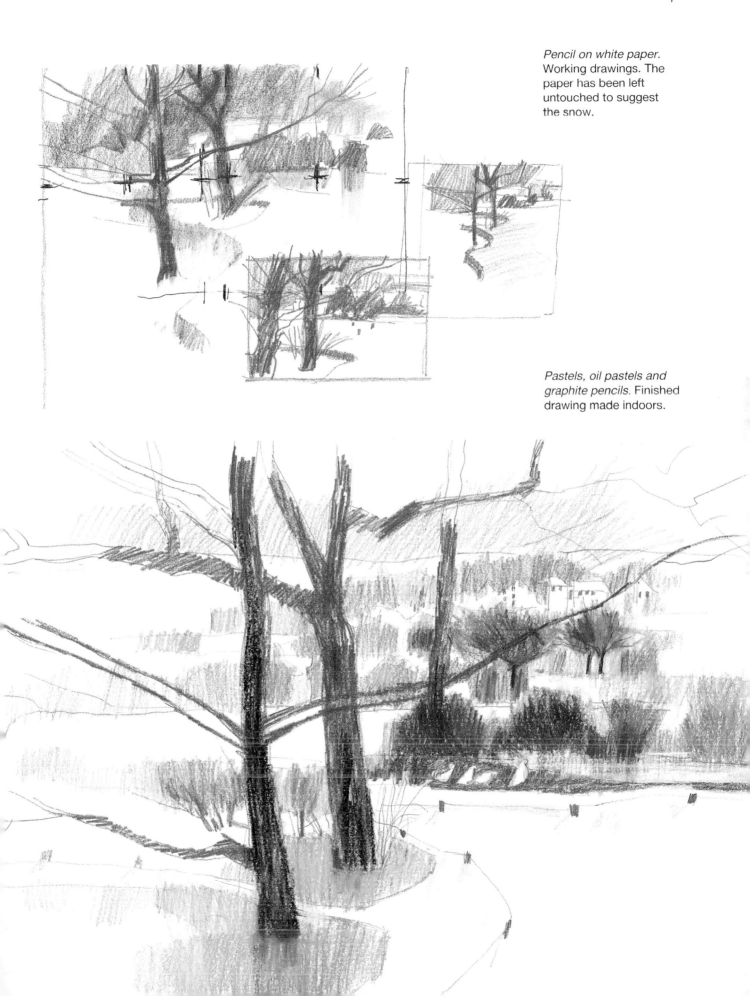

Pencil on white paper. Working drawings. The paper has been left untouched to suggest the snow.

Pastels, oil pastels and graphite pencils. Finished drawing made indoors.

PERSPECTIVE IN LANDSCAPE

Looking through your viewfinder, notice how the clouds at the top of the frame seem bigger than those nearer the horizon, regardless of actual cloud formation.

Why is this? It is simply one of the basic rules of perspective. The sky is like a roof over your head that recedes towards the horizon. The ground and the sky are the equivalent of the floor and ceiling of a great hall. Trees and houses, hills or islands are simply interruptions of the two main planes. Because we usually work from top to bottom of our paper we tend to forget that real life does not consist of a vertical plane; translating it from three dimensions into two dimensions creates this illusion.

Spatial perspective also affects colour. Things at a distance are seen 'through' air and even when the atmosphere is clear, its natural density will soften colours as objects recede, unless, of course, sunlight cuts through. The atmosphere is seen as bluish, so distant colours will become more blue-biased.

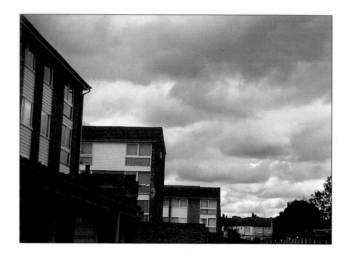

The perspective of clouds. Notice how the blocks of flats appear in perspective too.

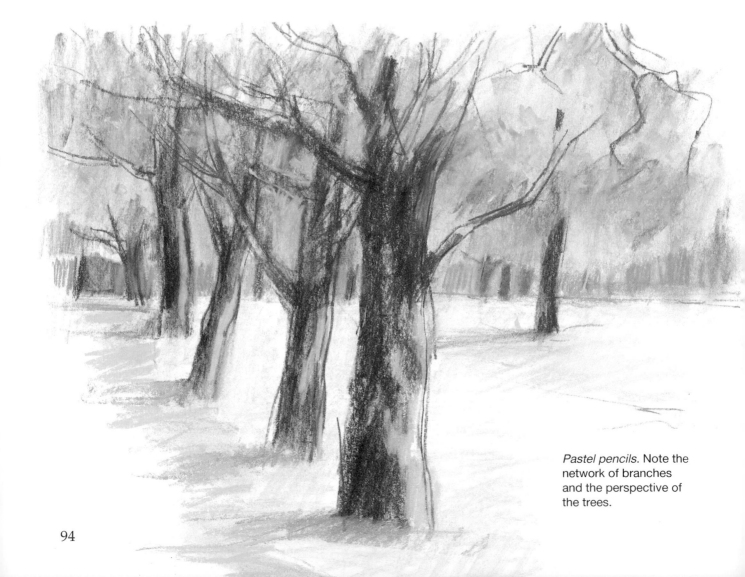

Pastel pencils. Note the network of branches and the perspective of the trees.

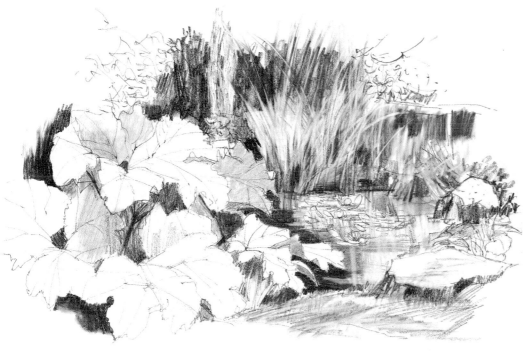

ABOVE LEFT *Broad pen on Ingres paper.* The seat adds foreground interest to this drawing of Regent's Park, London. ABOVE *Fountain pen and blue-black ink.* Drawn on the spot, using white space to suggest grass.

Pencil. Drawing done on the spot, on which the A1 pastel pencil study in Chapter 12 on page 136 was based. Although the leaves in the foreground are the main focal point, the reeds carry the eye to the rest of the drawing.

COMPOSITION

As we discussed in the chapter on towns, try to have something interesting in the foreground which will lead the eye to the focal point or will set the mood for the rest of the scene. However, space itself, as well as objects, can be used to balance or to 'push back' parts of the composition, or to suggest a surface without an identifying texture.

It isn't always necessary to draw a whole scene. There are lots of exciting corners of a landscape and choosing an unusual viewpoint – looking down at the roots of an old tree or up into its branches, for example – can make a picture both personal and distinctive.

If you use a bit of 'artist's licence' and move a group of trees, a bush or a cottage to improve the compo-

sition, make sure that the effect is convincing and that the scale is right: take care in relating their size (and that of animals) to the land and to each other.

Each time you go out, try to look at things differently. Look down for a whole trip, another time only look up, or through things – through a gate, a window, or a clump of grass. Refresh your seeing and explore with your eyes and your mind.

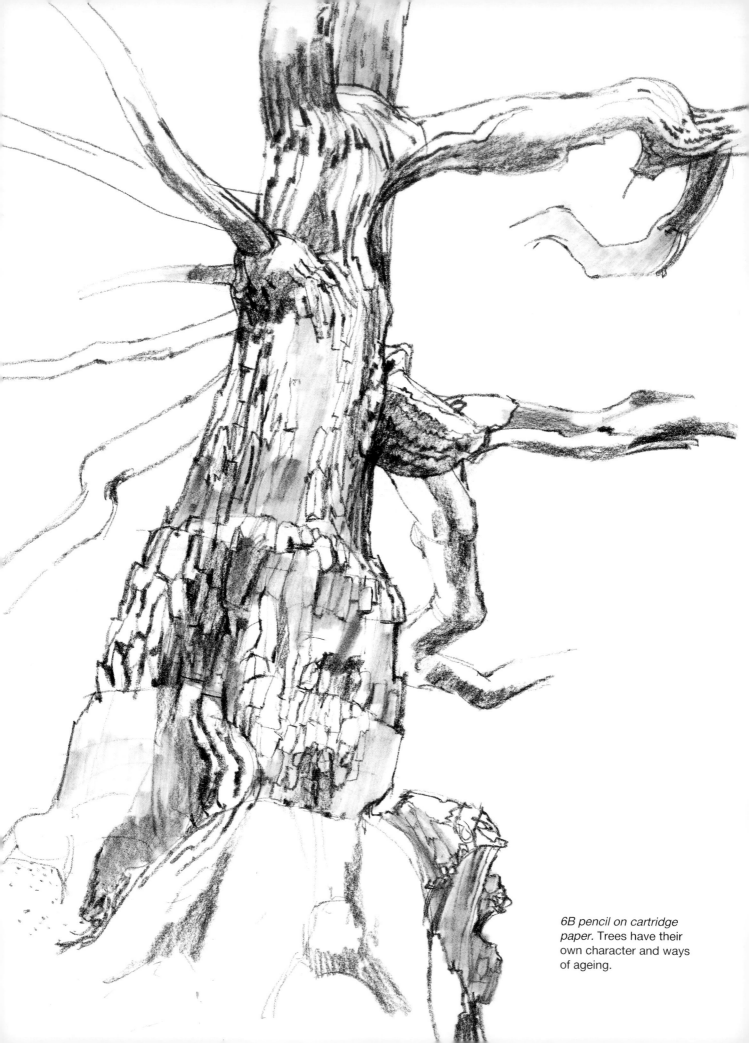

6B pencil on cartridge paper. Trees have their own character and ways of ageing.

TEXTURE

You should be quite expert at making different textures by now, but if it is helpful, recap on the earlier chapters before you set off for another day out.

Choose a landscape where there is a highly textured object or area that is near enough for you to see it clearly – a huge tree trunk, a haystack or a dry stone wall, perhaps. As you draw, make sure that the marks you make with your drawing tools are in scale with each other and with the whole. Keep the marks made for distant textures in scale with those for near ones. (I suppose we could call this the 'perspective of marks'.)

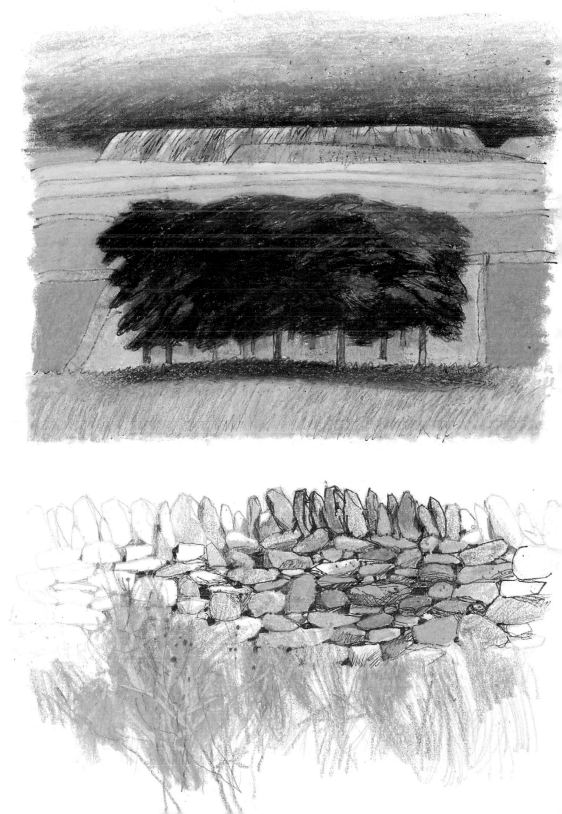

Clifford Bayly. Page from a notebook showing different textural treatments of landscape subjects.

Drawing trees

I am often asked, 'How do you draw a tree?' I once asked my tutor this and his reply seemed pretty un-helpful, although it did make me think. 'Well,' he said, 'this week I'm doing it like this (quick scribble), last week I did it like this (quick scribble), and next week I might do it like this (quick scribble).' The artist in question was well respected and with some re-flection I realized he was trying to say to me, as I do to you, 'Find out for yourself!'

Graphite pencil.

Pastel.

A tree in full foliage is quite daunting to someone armed only with a drawing tool. So, first identify a way of representing the texture of its foliage. Then identify individual masses of foliage and the direction of the light. (Don't choose a flat, grey day.) It may help to make your first attempt a sort of diagram, but this is only one of several ways of approaching the problem.

Compare your first attempt with the real thing and identify the subtleties you haven't put in. When you have researched that particular tree, find another which is quite different.

Oil pastel.

Water-soluble pencil.

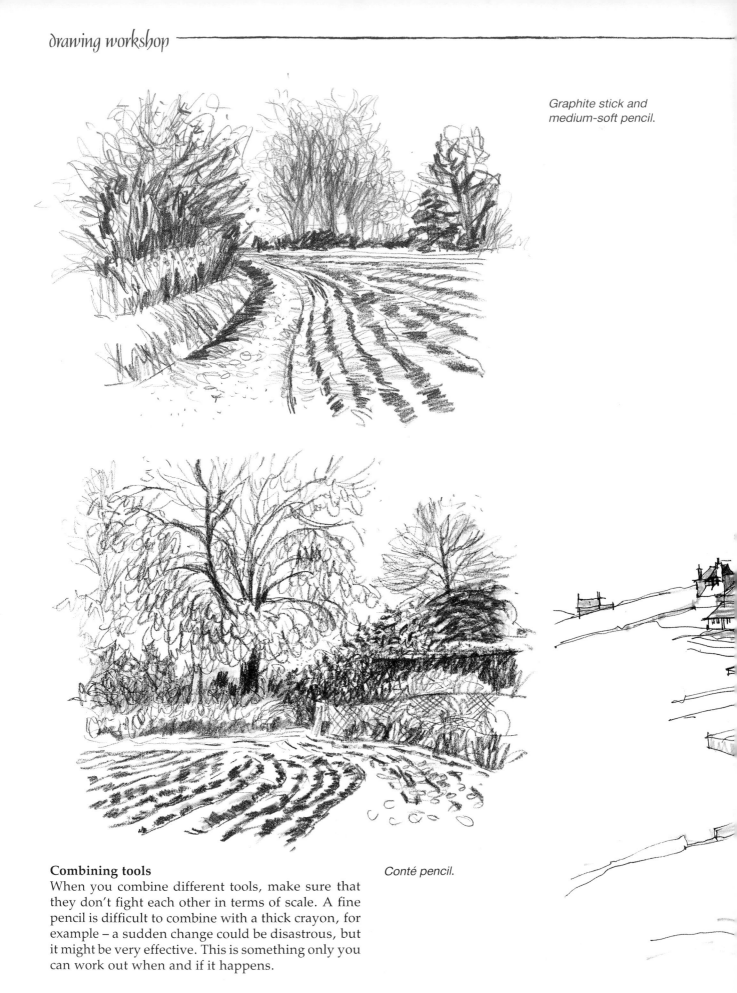

Graphite stick and medium-soft pencil.

Conté pencil.

Combining tools

When you combine different tools, make sure that they don't fight each other in terms of scale. A fine pencil is difficult to combine with a thick crayon, for example – a sudden change could be disastrous, but it might be very effective. This is something only you can work out when and if it happens.

Below Moira Huntly has used pen and felt-tips. The felt-tips add colour to her drawing without over-stating it, which shows that sometimes a sparing use of colour can be as effective as full colour.

TRAVELLING LIGHT

Painters often travel around carrying loads of equip-ment, but drawing is easier on the carrying arm. Limit yourself to one box (plastic food boxes are light) of mixed tools, a small bottle of water, one brush, some water-soluble pencils, a pack of tissues, and a can of fixative if you want to use chalks or pastels. Take a light stool and a medium-size spiralbound book or a sewn book which will open out flat to make a double spread, a couple of bulldog clips to keep your paper from flapping about in a wind, and that's it. A watercolour box is an extra, as is a 'lap easel', which is light to carry and can be used as a stabilized drawing board. Tie your stool to the board and put your box and pad in a bag and you're off!

project

Make a careful study drawing of any part of a landscape which really interests you. Make it as large as possible, using suitable colour to create mood. When you get home, re-do it as a very decorative 'flat' drawing, turning all the textural, tonal areas into a two-dimensional 'pattern', as you did with a natural form in Chapter 7. Even if you're not happy with the result, you will have gained by seeing what happens when you work on a complex subject in this way instead of on a single subject.

Moira Huntly, 'Llithfaen'. *Felt-tip and pen.* The colour emphasizes the main area of interest, which is set off by the open pen work.

10 seascape

Apart from the hazards of changing light and weather, drawing or painting the sea has the additional problem of the constantly moving nature of the subject itself. Some people find a 'formula' for representing it, but there is no one way to paint the sea. There are, however, many ways of approaching the problem so that you will gain enough experience to develop a personal style which is neither symbol nor formula, nor imitation.

FLOWING WATER

When you are running a bath or filling a bowl, watch how the water twists as it falls, see what happens when it hits the surface of the water, and how it spreads and joins, flows and moves. Try making some small drawings, including some in colour if you can. If you can do no more than make diagrams of flow and direction, this will help.

Moira Huntly, 'Chioggia'. *Pen and felt-tip.* An expert at drawing and painting boats of all sorts, Moira Huntly makes them the centre of interest by their placing, the detailed drawing and the strength of colour.

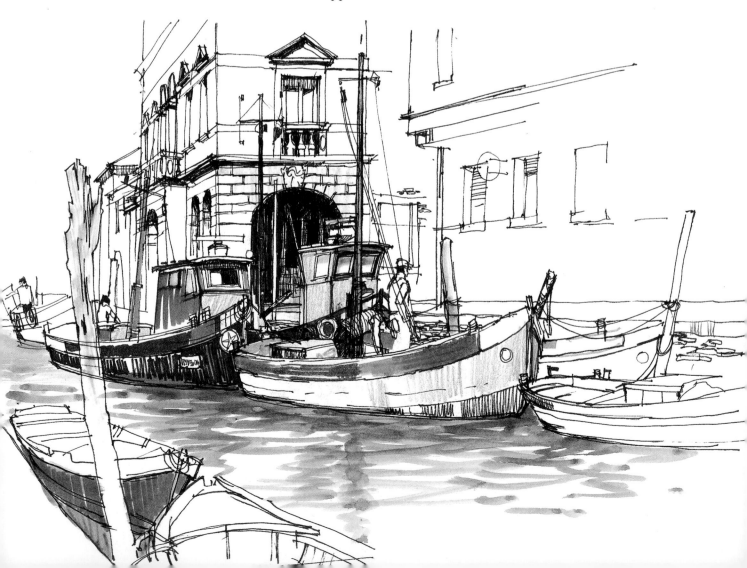

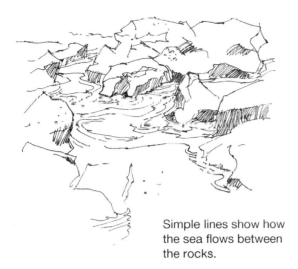

Simple lines show how
the sea flows between
the rocks.

Why don't you try this basic exercise many art
teachers used to give their students to teach them
about the tensions and dynamics of flow? Cut some
ovoids out of coloured paper to represent obstruc-
tions, and some thin strips of paper to represent the
water. See if you can make the flow move around the
obstructions in a logical way – and nature *is* logical –
as in the example included here. You could try the
same thing using matchsticks and garden pebbles in-
stead of pieces of paper.

It may seem to you that this has nothing to do with
the sea, but be patient: watching any flowing water is
a first step to understanding, and we have to train
our way of looking. Most of us just glance and think
we've looked thoroughly.

Swift-running streams are interesting, as the water
always has to change course to go around obstruc-
tions such as pebbles, rocks or small plants. If you
look carefully, you will see that obstructions have a
'knock-on' effect: the first obstruction will make the
stream move in such a way that when it reaches the
next, its route is predetermined.

Pastel. Logs in a river
create an obstruction to
the flow of the water.

Pastel. Try to work out
how the water would flow
around these rocks.

REFLECTIONS

How do reflections work? We know they are a mirror image, but just how much of the reflection, say, of a tree, will show in the water if the tree is set back from the bank?

A mathematical analysis of perspective can be found in more technical books on the subject, but the main point to remember is that, theoretically, the reflection starts from the point where the tree is rooted. Think of the ground between it and the water as an interruption and of the reflection as a 'continuation' of the mirror image. The examples here should explain this principle so that you can observe how it operates in practice.

When you are familiar with running water, go somewhere where there is a lake or pond. Choose a calm day at first so that there are not too many problems to deal with at once, and watch the way things reflect. If there are any water birds or boats look at the effect these have on the water. See how the V shape of their wake joins the other ripple patterns.

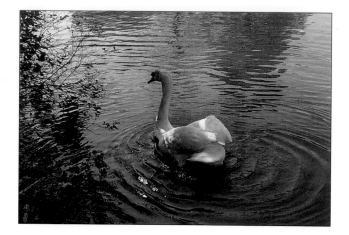

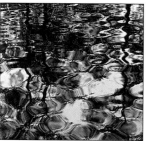

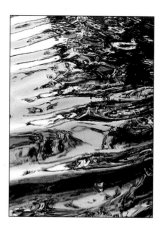

Reflections are distorted by the movement of water.

Although a reflection is a mirror image, allow for the distance between the object and the water's edge.

The appearance of reflections is also affected by wind or rain. Watching rain, unless you do it from inside, is only for the hardy, but is worthwhile. What happens when it hits the ground or the surface of a pond or large puddle? Very heavy rain rebounds from a hard surface and creates a sort of horizontal 'halo' effect. This would be difficult to draw, but put in some careful observation and make copious written notes to remind you in case you want to make a painting of this one day.

THE SEA

Now for the big problem! First the easy bit: the sea, however 'rumpled' its surface, is basically a horizontal plane and has the same perspective as pavements, roads or fields. Even large waves appear smaller the farther away they are. They also look closer together and flatter. Think about the fences discussed in Chapter 8 – the gaps between palings appear to get narrower the farther away they are, until the farthest part seems to be made of solid wood. If you turn a picture of a fence or balustrade on end, it will demonstrate the theory of receding waves.

Apart from the effect of the waves, the sea has very complicated movements. You may think you can get away with drawing little white worms on a blue ground, but this will never be convincing. We have to get back to looking.

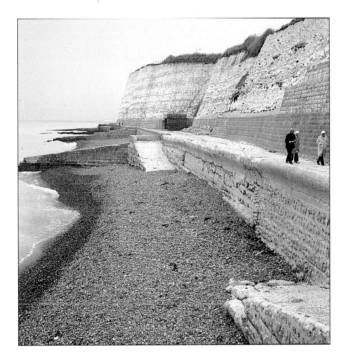

Look at the perspective of the beach, cliffs and the curves of the sea.

Ian Simpson, 'Rockpool, Beach and Sea'. *Pencil, ink and wash.* Note the different treatments of the sea in the foreground and in the distance.

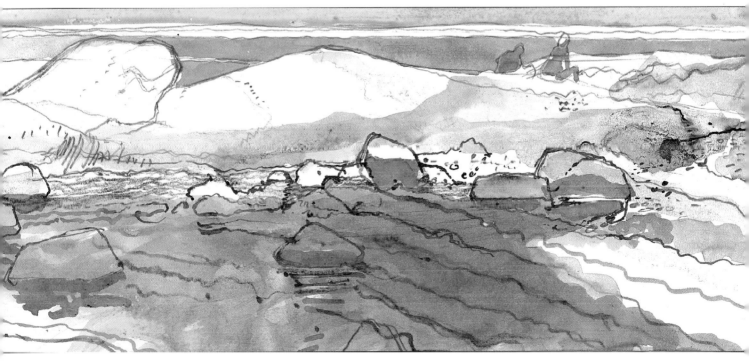

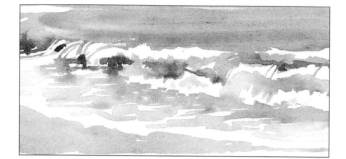

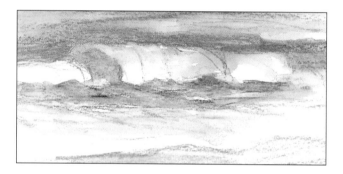

ABOVE In quick studies like these often all that can be done is to indicate direction and curve.

BELOW A colour note which suggests the 'feel' of the weather but lacks sufficient information for future use.

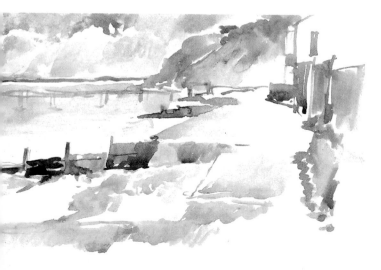

It is easy to be entranced by the moods and movements of the sea, for it is a great tranquillizer and can become hypnotic in its repetitive ebbing and flowing. You need to be alert and in a working mood in order to analyse how the waves move. Watch a small area in front of you – say 3 or 4 square metres; don't try to take in too much at a time.

Look at the direction, height, power and colour of each layer of waves as they arrive. Then watch what happens when they ebb away and make some diagrams of directions. Notice whether the waves move in straight or curved lines and where and how they overlap. Notice, too, how they break on the beach and what effect they have on the sand. Make a note of how the light affects them and how they appear when they are farther away. Look at the scale of the ripples and waves compared with the scale of the whole area you've selected and how they break or run around pebbles or rocks. Notice how boats are reflected in the water if there is very little sea movement.

When you are ready to move on, observe another area farther along the beach, or perhaps near a breakwater. Again, when you are fairly familiar with the patterns of movement, try to draw them. How about using watercolours now?

You will have been drawing with brush and inks sometimes, I hope, and drawing in watercolour (rather than painting) is similar. Keep the paint fluid, but not too wet, and don't worry whether you've got the exact colours; just make sure the tones are right. You can write colour descriptions on or by the side of your drawings.

With any landscape or seascape there is always a change in colour from foreground to far away, as we saw in Chapter 9. Not many people realize the subtlety of such changes. The colour of the subject itself can be quite surprising. The sea, for instance, can be mud brown as well as green or blue. Of course it depends on the weather and the reflected colour of the sky – which can be mauve or green as well as blue or grey; I have sometimes seen huge waves a lovely amber or gold-brown deep inside.

Many of you will feel that you are now making 'sketches' because you are having to work quickly, but providing your drawings are full of information, it doesn't matter what name you give them. This is a problem of labelling again. The fact that the sketches of skilled artists are often more interesting than the finished work of the less skilled has led to the idea that sketches are an end in themselves. But when an expert makes a sketch it represents a life-time's experience of what to put in or leave out, and how much can be left to a highly developed visual memory.

Boats and 'sea furniture'

From the artist's point of view, clinker-built boats – those made of wooden planks – are a great help in understanding the curves of a well-made boat. Smooth-sided, fibreglass ones offer no clue to these subtleties, so make your first studies of a clinker built boat if you can.

RIGHT *Fountain pen damped with water.* Dotted lines show the alignment of the prow with the stern, while the curved planks of the clinker-built hull emphasize the boat's curves.

BELOW Moira Huntly, 'Staithes'. *Pen and felt tip.*

One of the best ways of beginning to draw a boat is to compare its width to its length and depth. Make sure you identify exactly where the widest part is and that you place the centre of the stern in a direct line with the prow. Once these points are established, you will soon train your eye to see the rest fairly well. I find that the most difficult aspect is the way the curve 'bulges' at both ends and underneath; as each type varies, observe very carefully and draw lightly until you are sure you have got it right.

Reflections of boats in still water are mirror images, like those of other subjects, but the underneath of a boat also reflects, and this will have a sort of perspective. If you want your boat to look as if it really is in the water, watch out for this.

Coastal towns and villages have plenty of interesting objects to draw apart from boats: bollards for tying up boats vary in shape and size, and some are typical of a region; ropes should be studied carefully to see the way they fall. Try to show their weight, and don't forget that they are circular in cross-section, so the twists will go *round* and *over* the form. Rocks and rockpools, seaweed and bleached driftwood, mooring buoys and beaching machinery all supply foreground interest for a seascape. And in a fishing village there are boxes of fish and the fishermen themselves. It is no wonder that some artists devote all their time to the sea.

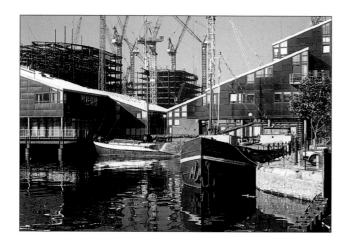

ABOVE LEFT Reflections of boats and cranes in London's Docklands. Notice how there are small tonal changes in the reflections.
ABOVE *Pen, pencil and wash.* Ropes. Such details are very useful.

Broad pen and ink on Ingres paper.

ABOVE *Pencil and colour wash* notes of rockpool formations.

BELOW Tree trunks used to stop erosion of the shore at Bradwell, Essex.

Pen and wash. Quick notes of heavy seas breaking on a jetty (right) and a pier (below).

Vitality and movement

If you can find a good place to sit and draw when the sea is rough, wrap yourself up, make sure the pages of your notebook or pad are anchored securely, and do the observation exercise again. Notice how the waves break and drain away, folding back on them-selves as they do so, and how there is a sequence of less high waves followed by the big ones.

The sea has enormous power and energy, so try to capture this on paper. How can you communicate the excitement of the crashing curves and the way a wave climbs before it breaks into spray?

*Pencil and colour pencil.
Waves breaking on a
slipway.*

BELOW *Pen*. A quick
drawing on cartridge
paper.

Make sure that any curved lines you draw have
'tension' and that they don't droop. You will avoid
this if you are using your tools freely and are able to
move your wrist and arm easily. If you are still clutch-
ing your tool and restricting its movement, curves
will have a limp look. Take a close look at the curved
lines in all the major drawings in this book to see
what I mean. Flower stems and thin tree branches
often show this weakness in the work of beginners,
but it is simple to put the problem right once you are
aware of it.

project

1 Make diagrams (not the same as mine!) of water
flowing – you could choose a small stream, rain
running down a window pane or water in a bath.
When you are satisfied you have captured the
characteristics of the movement, make some
coloured studies and then incorporate them into a
composition – a still-life with a bath, a landscape
with a stream, or whatever.

2 Find some still water with boats or other 'furniture'
and make a drawing using pastels. Make the most
of any textures natural to the subject and try to get
the reflections right.

3 If you can get to the sea, choose a composition
and make two drawings, one in black and white
with colour notes written in, and a second one of a
different part in colour.

4 Make a drawing of a group of rocks in water.

WORKING FROM MEMORY

Years ago I paid a visit to the Niagara Falls in Canada. Most artists are familiar with 'sight size' – if you shut one eye and hold a pencil up to your subject, a face not very far away will appear to be only a couple of centimetres long. So Niagara from a distance appeared quite small. Close up it was overwhelming.

As well as taking snaps like other people, I looked and looked. I watched, fascinated by the millions of droplets which hung in the air like a cloud and had their own rainbow, and I watched a little boat bob up and down below. Within half an hour the thundering noise and the intensity of light from those millions of droplets had brought on a migraine.

During the two-hour journey back I shut my eyes against the light and tried to visualize all I'd seen. As soon as I could, I put down on paper what I remembered. The pastel drawings here took about fifteen minutes each and when my photos came back I found that the drawings, however rough, were very close to what I'd seen – so looking does pay off!

These three pastel drawings are about A3 size.

II *people, animals and movement*

The human figure is one of the most difficult subjects to draw. Not only is it as complex as any tree or building, but it moves, and as it moves it changes its form in subtle ways. Books on anatomy show how the bones and muscles articulate, but usually in 'frozen' poses; they rarely show how muscles and bones work when the subject is in motion. In the nineteenth century Eadweard Muybridge did try to do this by recording the moving figure in photographic sequences – but even these are no substitute for personal observation and study.

Life classes are meant to help us study the human form, but the help they offer is limited. Few models are required to move much, so 'life' drawing is often static, posed and 'life-less'. A session of quick poses showing some activity would be much more helpful.

Raymond Spurrier, 'Rustiques, near Carcassonne'. *Soft pencil.* The figure has been put in when it appeared, after the tractor had been drawn.

Human beings in everyday life do not pose; they might 'strike a pose' but even that has gone in a flash. So how do we set about drawing such complexities?

WHAT TO LOOK FOR

One day when you feel like a change from your indoor studies, take your small notebook and find a secluded corner in a café or bar. Watch. Don't draw, just look – although preferably without staring! Most of us stare when we are curious or look without seeing but now is the time to look with real observation and a sense of enquiry.

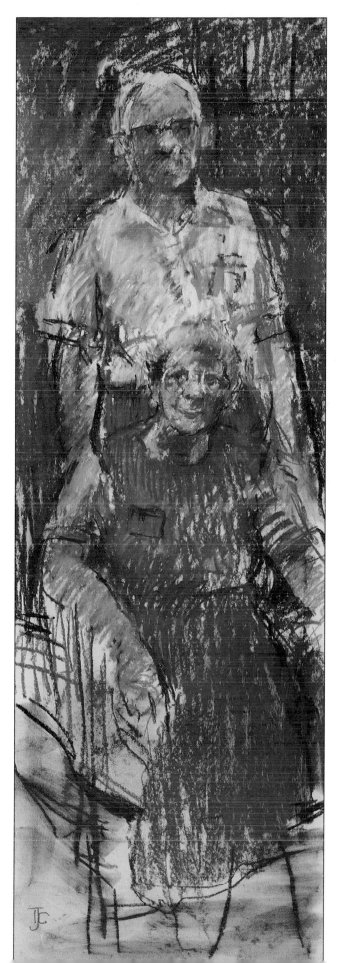

RIGHT Tom Coates, 'Husband and Wife'. *Pastel.* A less usual, but very effective, way of placing two sitters.

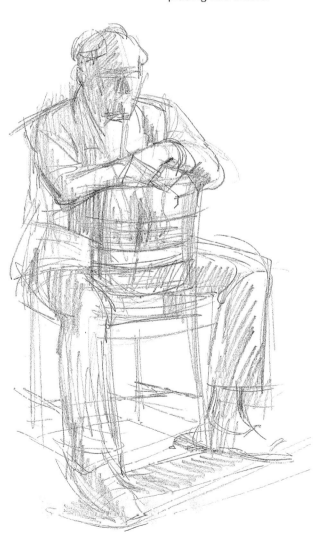

Pencil. Ten-minute drawing from life.

Stan Smith. *Pencil.* Notice
the way the hands hold
the mug and the hunched
shoulders – a typical
position when a drink is
comforting.

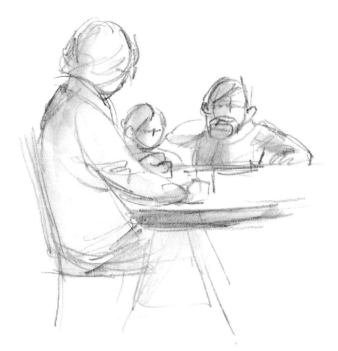

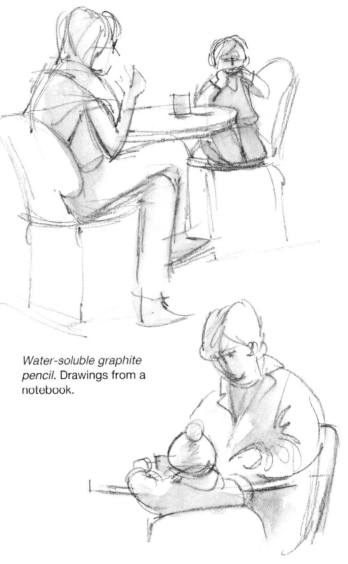

A woman is bending over to speak to her child on their way to a table. Notice how far her head is above the child's, and the slant of her shoulders. Notice how she bends – from the knee or from the waist, or does she squat to be on a level with the child? Now they are sitting down and the mother leans towards the child. Look at the angle of the head, and, again, the size of it compared to the child's.

Body language is very personal and can help you portray character and personality in your drawing. Look at a few people and compare, say, the way they turn their heads or the way they move their hands in conversation.

Water-soluble graphite pencil. Drawings from a notebook.

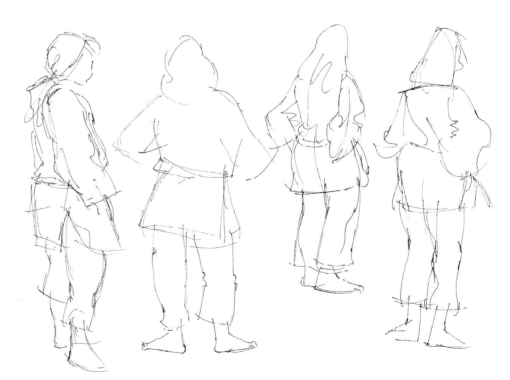

Pen. Body language typical of competitors watching judo.

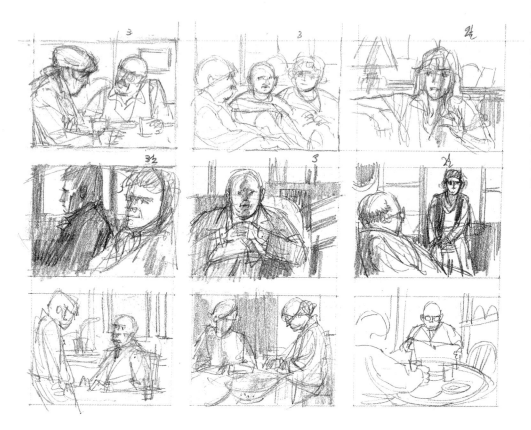

The figures above the rectangles indicate how long each drawing took. This is not something to aim for; it is just to give an idea of how much can be done in a short time after some practice. Note the different ways heads and hands are held when a person is talking.

When you can conjure up a really accurate picture of someone sitting at a table, try making a few visual notes. If you are drawing from memory and not looking up and down from your book, you should not attract too much attention. The close-your-eyes-and-visualize technique may help.

Another way is to use television. Pick a programme where there is very little action – a chat show, for example. On a page of a notebook draw four rectangles representing the television screen, about 5×4 cm (2×1½ in). In one rectangle make some direction lines to indicate a pose, and when the person moves do the same in the next, returning to the first drawing if the person resumes that position. Draw lightly and leave all lines in. You are learning to observe and the quality of your drawing is not important yet. Anyway, 'think' lines can create a vitality of their own.

If you prefer, concentrate on one part of the body at a time – on hands one week, feet the next, on heads, then bodies – until you can cope with complete poses. Find your own way of dealing with moving subjects from life.

Observe the size of hands and feet relative to bodies especially carefully. Few beginners get these proportions right. Most of us make hands and feet too small when we start. If you date every drawing, in a year's time you will see whether you have learned to avoid this pitfall.

tip

Put the heel of your hand against your chin and spread your fingers. You will find that the top of your middle finger comes at least halfway up your forehead. A spread hand virtually covers a face. Measure your foot and you will find surprisingly little difference. This will not help you to draw well, but it may help you to be realistic about relative sizes.

Charles Keeping, 'Charlie, Charlotte and the Golden Canary'. Look at the posture of both the old man and the child.

The pose and overall shape is more important than detail in these twenty-minute drawings from life.

THE POSE

If you have any friends or family who will sit for you for an hour, then use them. Get your model to sit on the floor, head on knees. How do they relate to each other? With hands hugging knees, look at what happens to the curve of the back; twisted on a low stool, notice where the knees come in relation to mid body, and where the hands are in relation to knees, and so on. Look at the folds of clothes, remember how they can help you to create the 'outline'.

Put in the direction lines of poses and don't rush things. Keep your lines loose and light and your hand easy and free on the paper. Don't keep lifting the point of your drawing tool from the paper, just pause each time you look up. (You should spend more time looking at your model than looking at your paper.) Leave out all details.

When you are drawing a shape without details, like the head, learn to estimate the shape with careful observation. The head is not an egg on a thick stalk as some 'how to' books show; the spine joins the skull at a higher point at the back than the chin sticks out at the front. And don't be fooled by hair. Hair covers the skull and allowances must be made for the skull underneath it. Feel your own head carefully – in fact feel every part of your face, trying to visualize it.

Surroundings

Wherever and whoever you draw, try to indicate a little of the setting, even if it is only by a few lines, so that you get used to establishing this relationship. It's much more difficult to learn to use surroundings later if you have excluded them when first learning to look at the figure. Surroundings give scale and a sense of being somewhere. Sometimes, of course, lack of time prevents this, but always be aware of the relationships.

tip

If a figure is standing but is not evenly balanced on both feet, the hollow at the base of the throat will always be directly above the inside ankle of the foot bearing the weight. If it is not, then the figure must be supported in some way or it would fall over (unless it is someone like a dancer, who has been trained to balance in special ways).

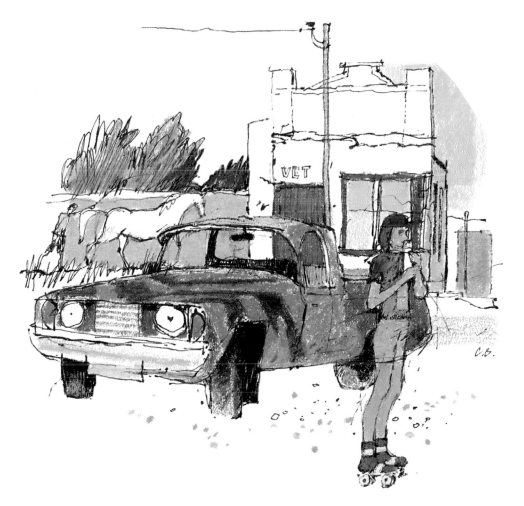

Clifford Bayly, 'Vet's Surgery'. *Pen and oil pastel.* Human perspective, although subtle, can be seen clearly in the figure of the boy.

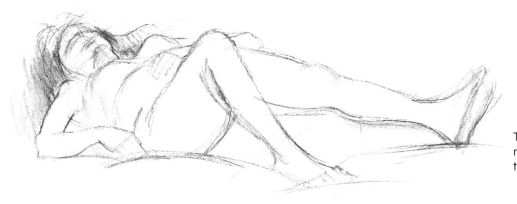

This reclining figure shows marked foreshortening of the upper torso.

PERSPECTIVE OF THE FIGURE

The fact that the figure has perspective is very noticeable if you lie on the floor and look up at someone. Of course this is not a usual viewpoint and in normal circumstances one is rarely aware of the problem, but to understand how it works, imagine a flat wall stretching away from you. You are familiar with the perspective of that. Now imagine a figure with its heels and back against the wall and its arms spread out flat against the wall. Do you see that the figure will be following the perspective of the wall for a short distance, albeit not enough to be obvious?

If you understand everything so far, find a friend who will sit for you so that you can attempt a straightforward drawing. Don't worry about details like features yet. Be content to get the pose and perspective right, the proportions right, and the clothes and hair wrapping over and around the form. Watch for body language if the figure shifts at all.

FIGURES IN A SETTING

When you are in a bus or just waiting somewhere, look at people in terms of shape. Simplify shapes but never resort to drawing match-stick figures – always allow for the solid form which occupies space. If you want to draw scenes with people in, then the figures, as much as objects in the setting, will occupy space on your paper. Start making notes of overall shapes of people doing different things. The stance of the figure will affect the shape.

Find somewhere unobtrusive where you can watch people doing some sort of repetitive manual work – ironing or digging the garden, for example. Watch how they work and how their bodies and hands move, how their heads tilt and how they balance. When you are very familiar with their working patterns, make some drawings of them.

Raymond Spurrier,
'Kremasti'. *Soft pencil.*
The figure, added to the
scene when it arrived,
adds scale as well as
human interest.

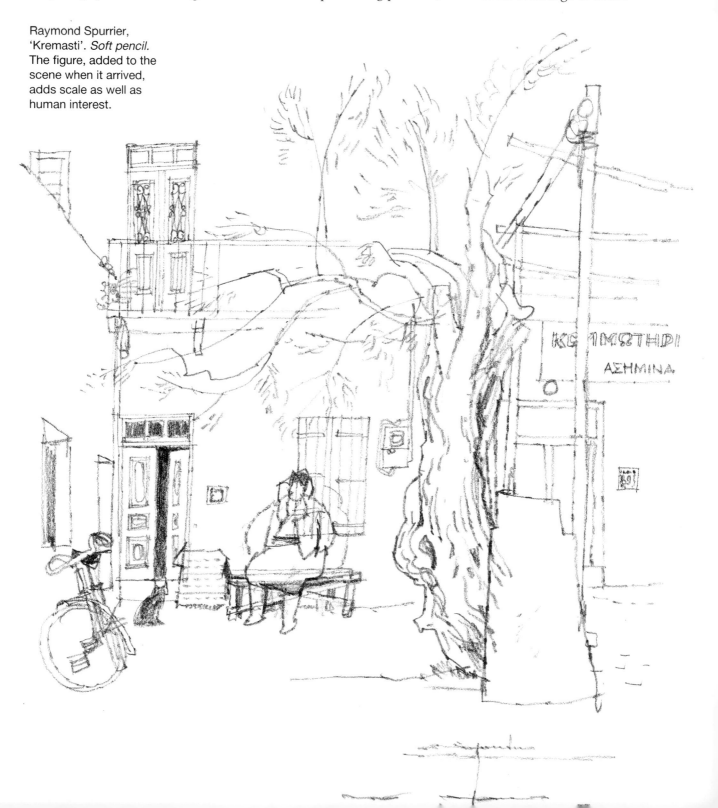

Stan Smith. *Pen.* Children have their own way of sitting.

Stan Smith. *Pencil.* The figure has been drawn very directly and tone applied broadly, but there is strong and subtle detail in the face and features.

CHILDREN

The proportions of children vary with their age and development, so there is no substitute for observing a living model. A child's head becomes smaller relative to its body as it grows, and its feet often seem comparatively large. (See illustration p. 119.)

Children are interesting in the way they stand. They stick their stomachs out, cross their legs or turn their toes in, as you will see if you watch some children in a play area. Try to be unobtrusive but be prepared to explain your motives to anyone worried about them. I remember once taking photographs of children playing, as reference material for a book I was illustrating. After a while I realized I was getting funny looks from some parents, so I went and explained what I was doing and why, and their faces cleared.

ABOVE *Pencil.*

BELOW Dee Chase.
Conté pencil.

PORTRAITS

This is one area where most people just don't know where to start. Experts will have devised their own way and that varies from artist to artist. Before you begin, explore your own face bit by bit more thoroughly than previously. Try doing it now, while you are reading this. Put your fingers at the side of your temples and feel the flatness there, move them down and across the cheek-bones, visualizing how these come forward. Move up to the more sunken area under the eyes, then up over the lids to the eye-brows. Move your fingers from the inner eye across the lids to the temple. Visualize. Start again at the temples and move your fingers down the face from mid-cheek past the nose and mouth, ending up at the chin. Move from the chin either side along the jaw-bone until you reach the hollow just behind the ear. Move out from in front of these and back to the temples – and so on until you can visualize the form as a sculptor does.

I have found that it is easiest for beginners to draw someone sitting opposite them straight on. Find a friend to model and sit either side of a table. If your friend is co-operative, both of you could explore your own (or each other's) faces with your fingertips. Do it slowly, looking and understanding. (If you can find no one to sit for you, read on until you reach the section on self-portraits and then apply what you have read here.)

Beginning to draw

Whatever you do, don't start by drawing an outline of the face. Start with the eyes. Note and mark the distance between them and how this compares with the length of the eye itself. The eye is not a pointed oval with a squashed-looking eyeball sandwiched in it! The eyeball is a sphere over which the lids rise and fall. There is a duct visible in the inner corner, but none in the outer.

When you have drawn the eyes reasonably, move out to the temples, then either up to the forehead or down to the cheek-bones. Continue like this, always relating the various parts of the face to each other. Note how the mouth grows out of the flesh over the teeth and jaw.

Some people's jaws jut out, others have receding or straightish ones. Look at your model. The portrait left was made, using the method I've just recommended, by an adult with no experience in portraiture. It is a good attempt at showing form using line rather than outline.

Noses and necks

Although it may seem obvious, the nose, like the mouth, grows out of the face, and is not something just stuck on. The nostrils and the corners of the mouth are convoluted, subtle forms which must be observed carefully, as must the bridge of the nose and its relationship with the eye sockets.

Necks are interesting in that the muscles of the back come over the shoulders rather like a triangular scarf and the muscles running from behind the ears to the breastbone enable the head to tilt and twist sideways. Muscles stretch just like elastic. Try moving your head slowly and visualize your muscles as pieces of elastic. With your hands, feel the way they work.

With children, these things are more difficult to see as their flesh is soft and the muscles are not fully developed. They are there, however, and understanding this will help your drawing.

Character

It is not always necessary to draw features in detail in order to depict a likeness. After all, we can recognize friends from the back, or in shadow, where features are indiscernible. So what makes a 'likeness'? Think about this carefully and draw only what is necessary according to your personal style. Look at the different drawings here and see how varied they are. Very few are detailed descriptions, yet I'm sure we would recognize these people if we were to see them. People – adults and children – are characters from top to toe, and so are artists. One sort of character has, therefore, to find a way of representing another. If you are one of those people who likes to draw others, this problem can be a delight and a challenge.

Pencil used loosely to catch a pose quickly.

SELF-PORTRAITS

It is useful to make a self-portrait as often as possible. We can control the pose, the time we take, and the number of attempts we make, since there is no model fretting about having to sit still. There is also time to try out different drawing tools, methods and styles. We can work big or small, in colour or black and white. Look for light reflected from clothes or walls. This is particularly noticeable in the chin area.

Take your time and look hard when your head is still, but remember that when we concentrate we tend to peer, which is why eyes in self-portraits often seem starey. Try to relax and be aware of your posture, so that your muscles and features aren't tensed.

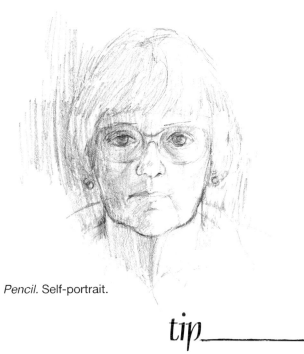

Pencil. Self-portrait.

tip

When you are drawing you look down at the paper and then up at your face. Most of us do this movement quite quickly so we may not always see our faces in exactly the same position. Often this results in making areas like the forehead far too elongated. If you mark on your mirror where the centre of your forehead reflects, this will help you make sure that your pose is the same each time you look up.

125

The general feeling of stance captured in this photograph could be drawn very quickly when you have had some practice.

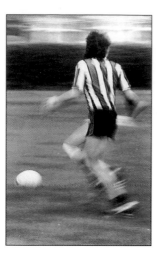

SPORT

If you enjoy sport, here is yet another opportunity to draw figures. A rugby scrum is a good starting point, as it is easier to draw than figures chasing a ball. Any sporting event will supply you with subject matter, even if it is only the spectators on the sidelines.

Never bother to erase lines. Keep them free and easy and light, simply adding new ones until the drawing gets clogged. As you did with your television poses, start one drawing and move on to another, returning to a previous one as a figure takes up that position again. Your first attempts may look a mess, but why worry? The end result is not important, but the doing is.

These judo competitors held the action for a second to allow me a fraction more time to draw them.

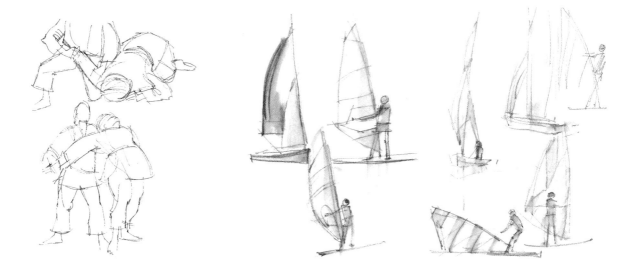

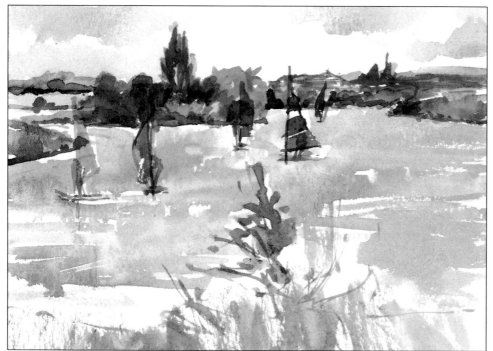

ABOVE *Water-soluble graphite pencil* damped for tone. Drawn on the spot.

Watercolour. Page from a notebook. The drawing took ten minutes.

All these drawings were made from life with different types of pen. Watching the repetitive movements which birds make helps you grasp their character in a few seconds.

Stan Smith. *Pencil and paint.* Soft feathers and hard legs are treated differently.

DRAWING BIRDS

If you have a garden and a bird table, you will have no shortage of subjects. Otherwise, take a large bag of small breadcrumbs to the park, fairly early in the day before other people have fed the birds. Crumbs are better than bird seed as they're bigger and easier to throw, a few at a time where you want them. Birds won't pick them up so quickly and will sit around waiting for the next helping; they will scratch, wriggle in the dust or preen – and if you throw more crumbs just as they begin to fly off, they will come back again. Sparrows are full of character and hang around for quite a time.

Use your small notebook and do small drawings, or the birds will be off before you're half-way through. Keep several drawings on the go and add to each as more information is presented and observed. A watercolour pencil can be useful, as you can draw with it dry and then add water (and hence tone) when you get home. A lot of patience in watching and waiting is needed, but if you choose a pleasant day in a pleasant setting, what more could you want?

DRAWING ANIMALS

As with drawing the human figure, I think it is better to start drawing animals from personal observation before you look at books on animal structure, which can be very intimidating. Following theory too closely can kill the freedom and joy of drawing. Use books to help you understand the theory in the light of your own efforts and then apply it intelligently.

Learn to see directions between points across form, like the angle of the pelvis when the body is turned or the balance uneven. Look for the same sort of comparisons you used when drawing moving figures.

It is important to realize that animals' overall bone structure is similar to ours – even if they walk on all fours and some of their joints are reversed. They may not have necks, kneecaps or ankles as such, but they have an equivalent. Observe them carefully and work out the order in which they move their legs. (Eadweard Muybridge, whom we mentioned earlier, also made sequences of photographs of animals in motion to establish this.)

Start by watching and remembering, as with any drawing. Try slow-moving animals at first, like elephants or rhinos, and work up to faster-moving ones as you gain more experience. Sleeping animals are an easy target, although they sometimes wake up and move right in the middle of a drawing!

If you have a riding stable or a pet shop near you, how about asking for permission to work on the premises? To spare you embarrassment, though, do make sure you have had plenty of practice first.

Cats are perfect models because they are more relaxed than most other pets. A cat will 'pose' in any position from the totally relaxed sleep to the slow, ready-to-pounce creep. When you can cope with speed, watch its skittering response to windy weather. (Incidentally, next time it is windy, go out and see how it affects the way children and adults move – their speed and body language.

Use television if you have no other way of seeing animals in action, but don't succumb to the freeze-frame or slow-motion buttons if you are using a video. Stick to the normal speed and don't fool yourself into thinking you are drawing the real thing.

Stan Smith. *Pencil and paint.* All these drawings were done on the spot at the zoo. With great economy of line Stan Smith conveys the animals' character.

project

1 Draw a self-portrait with coloured chalks or pastels.

2 Make a drawing of someone doing something energetic in more or less one spot, like skipping, digging, washing their hair or cleaning windows. Use a very soft pencil and smoothish paper. Make a note of all the problems which arise and try to solve them ready for next time.

3 Using water-soluble colour pencils and dry graphite pencils make several drawings of a group of people watching something. Use the colour for tone and add water when you get home; use the graphite pencil for catching the poses quickly.

4 Using a soft Conté pencil, draw some young children at play.

5 With compressed charcoal or a charcoal pencil make a drawing, using tone, of an animal at rest — from life, not from television.

6 Make at least thirty drawings of a bird moving (from life) using a fountain pen, a ball-point or fibre-tip pen.

7 Using any tools, make a series of drawings of an animal in fairly fast movement.

12 projects and progress

It has been said that there is nothing truly original any more and to a certain extent this is true, as we are conditioned by our genes and influenced by our parents, where we are born, the circumstances and age in which we live. In art we are also influenced by the art we see, its quality and attitudes. Many people regard anything they don't understand as 'modern', but old masters were modern in their day and some artists were so badly misunderstood then that they died in poverty, while now that the general public has caught up with their ideas, their work is worth a fortune.

What has all this to do with drawing? As artists – beginners or advanced, amateurs or professionals – we should all have something to say, not only about the things that interest us, but about our era – non-classical, ephemeral and materialistic, yet aware of more important issues.

Suppose you are one of those people who still feels confident only when there is something in front of you to be drawn or, a terrible state to be in, when someone else suggests something? I have known amateurs completely at sea when their tutor, who has always told them or showed them what to do, leaves. Students are then without any way of continuing on their own or of finding a personal way to work. You will probably see quite clearly now why I recommend finding everything out for yourself rather than taking the 'how-to-do-it' route.

Suppose you have drawn and drawn, and have found no particular subject which offers any immediate attraction. How do you set about finding 'your own thing'?

Use this book to spark you off, to point the way and to start you thinking and working for and by yourself. A lot of professionals have been self-taught and the best, of course, are those who have the willingness to devote their time to working hard and intelligently – and have integrity and sound judgement without having huge egos.

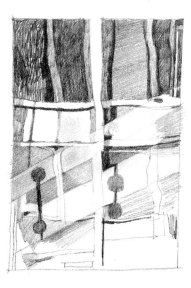

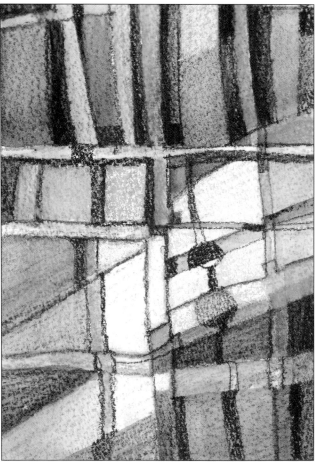

ABOVE RIGHT Notebook drawing of reflections in a window.

RIGHT *Pencil and water-soluble coloured pencils on rough watercolour paper.*

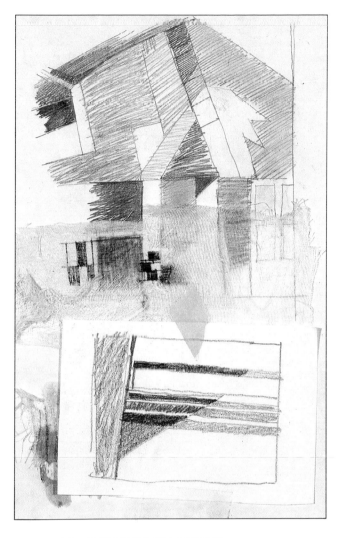

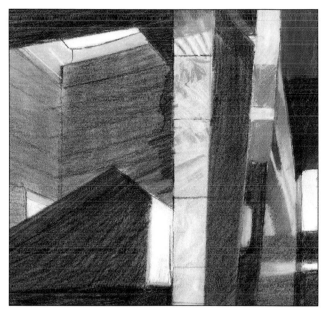

LEFT A 'think' sheet from a notebook with drawings of small areas of a building.

ABOVE *Pastel pencil* drawing sparked off by notebook work. Although the drawing is only 30 cm (12 in) square, the scale is large.

SETTING YOURSELF PROJECTS

Every artist of whatever ability can 'dry up' sometimes, but people who say, 'I only like this or that,' will always be limited. Keeping an open mind will help prevent you from running out of ideas. If you do find you don't know what to draw, never resort to copying a photograph or someone else's work. One solution is to set yourself a project. You may think a project is something set by a teacher, but I use the word here to mean a series of drawings or explorations, a starting point which could lead anywhere; at best it can open new doors and keep you going.

So how do you choose a project? We have an ever-present source of ideas in that every living thing changes, it grows, lives, dies, gets fat or thin, and so on. Even inanimate objects are changed, and our way of looking at things and our thoughts about them change too. You could set out to explore this theme of metamorphosis through a series of drawings, taking a bread roll, a leaf or an unwanted old mug or cup as your subject. I took an apple for mine.

Pieces of patterned china make an interesting project. These pieces could be re-arranged again and again and drawn in different ways.

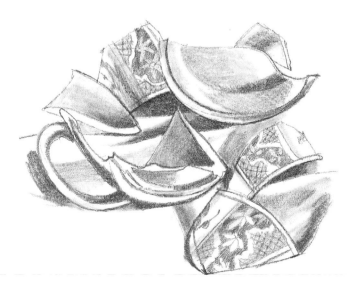

As we bite into it, an apple not only changes shape and form, but with exposure to the air it changes colour; a leaf, as it dies, begins to curl in on itself; if we tear a roll or hit a piece of crockery with a hammer they will change in characteristic ways. An apple will break crisply, a bread roll has soft or crisp textures, china will have bright sharp edges, and the leaf fractures into pieces when it is dry.

While I was drawing this picture of an apple I was fascinated that after the first bites, however I broke it with my teeth, distinct facets appeared. The exposed flesh did not go brown for quite a long time and I discovered that there was far more variation in the colour than I expected.

Things don't always have to be destroyed to explore the theme of metamorphosis – they can be added to or merely changed. But whatever you try your work will be the constructive aspect. A lively, discerning mind, an observant eye, a passion for investigation and an ever increasing technical ability can produce work of real interest and vitality.

Pencil and watercolour. The first drawing and sheet of studies developing the idea of metamorphosis.

Ideas from words

A word can begin a train of thought which leads to a possible project. Take a word from a dictionary, such as *heavy*. What does it suggest? Weights? Boxers? Muscles working, or a television advert about lager?

Think of *heavy* and *light*; you might want to draw a heavy object lightly and then heavily, superimpose one on top of another, draw some weights, a weight-lifter, a woman carrying a heavy shopping bag, or a shopping bag bulging with goods, a pile of bricks.

Circles might make you think of manhole covers, wheels, bracelets, haloes, or the moon and sun. Why not go on a circles hunt and look for anything circular or spherical and see how they might work together after you have drawn them.

Ask yourself questions and find the answers by drawing and investigating. Try the word *edge*. Be careful how you translate your idea. For instance, a drawing of cliffs with sharp edges will be merely a drawing of cliffs unless you treat it in a specific way; the method and viewpoint you use are important. Look at the decorative patterns of jagged edges, and the frayed, worn or hemmed edges of cloth. Do you see how thoughts can supply you with ideas? Match your ideas with drawings and see where they lead.

Ideas from things seen

This time, try a subject rather than a word. Find a handful of small objects which are similar in character but have variations. When I started to draw these toffees I very soon found that I was more interested in the twisted ends of the striped wrappers than in the form of the toffees themselves.

In Chapter 4 we looked at the Henry Moore sculpture and saw that interest can be gained by looking through things or by having the view interrupted in some way. We can see through the stems and branches of plants, through curtains, holes (and ghosts.) Let each piece of work take you to a point where there is nothing more to be done with your subject. This is the way you recognize that a piece of work is finished.

This drawing was framed with masking tape to see if it offered promise as a composition.

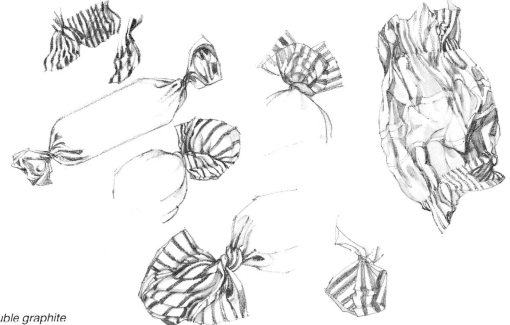

Water-soluble graphite pencil.

The environment

If you still have a 'block' about what to draw, how can your town, village or place of work be of use? Look at it as if you've never seen it before and make a number of small drawings exploring any one aspect. Research things like variety in textures, groups of bollards or other interesting street furniture, odd corners, chimneys, fences or gates. In other words, draw a portrait of part of your environment. This is really an extension of what you have read in other chapters, except that now you are investigating single aspects in greater depth. One idea for a project is to make a key drawing of an area where you live and chart the tonal changes from dawn to dusk.

What happens when you place an object in an alien or sympathetic environment? Take a natural object like an egg and draw it in a variety of situations – cradle it in one hand, put it on a piece of darkish velvet or towelling, in a 'nest' of twigs or bits of string, in rough wool, in a basket, on a hard floor or in a transparent bag. Each relationship will evoke a feeling or emotion because of the association.

All of these experiments will add up to what we refer to, colloquially, as 'doing your own thing'.

Pastel compositions based on toffee wrappers.

Small notebook drawings
of windows and trees
reflected.

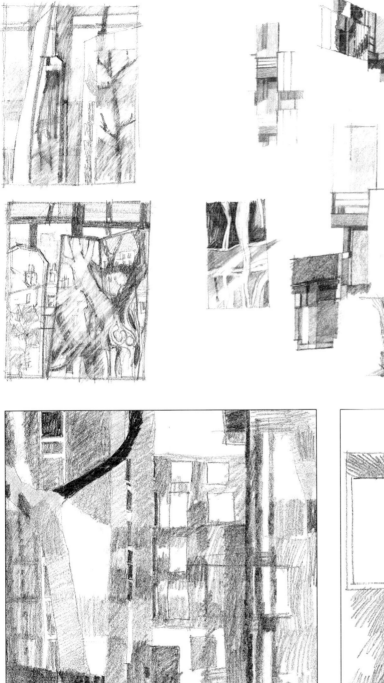

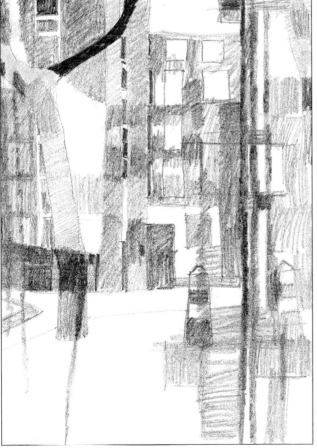

BELOW A2 drawings
developed from the small
notes above.

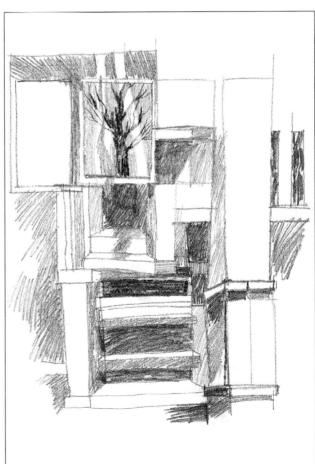

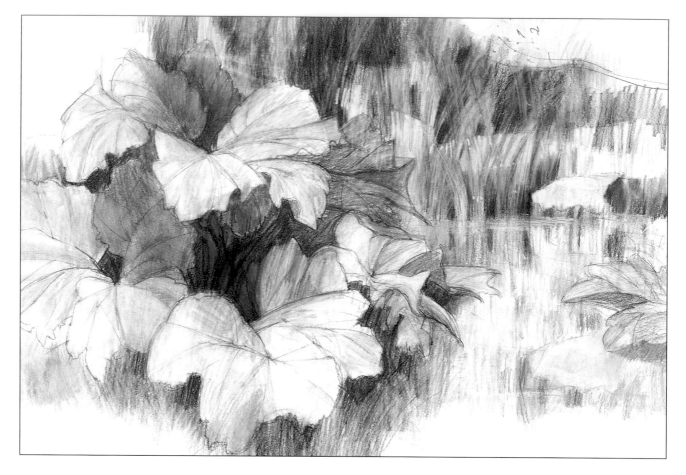

USING YOUR NOTEBOOK

In Chapter 8 I mentioned that a good notebook could keep you drawing for months. In fact, if it is bulging with informative and interesting drawings and notes, it can feed your mind for years ahead. Cuttings, colour swatches, anything with tactile qualities can also be stuck in to remind you. Of course, if you already have such a notebook, much of this chapter will be superfluous as you will never run out of things to draw. Never throw away a notebook that is full of information, even if the drawings are poor; a notebook is like a diary – for your eyes only.

Straight study drawings and copious notes, whether in a notebook or not, are basic to developing your skills. Give some thought to how you use your notes and drawings. If there is a single drawing packed with information, you may be able to 'blow it up' and translate it fairly directly into a different medium, as I did with my leafy pond drawing in Chapter 9 on page 95. It was made on the spot with pencil, and then enlarged to A1 size for the pastel drawing here. Another way is to take the first drawing and interpret it in a number of different ways. See how this student interpreted her on-the-spot drawing of part of the Eiffel Tower.

ABOVE *Pastel pencil.* A1 drawing based on the pencil drawing on page 95. The corners were left deliberately to give an open feeling. The reeds on the far side of the pool were treated decoratively as a foil for the more realistic treatment of the large leaves.
OPPOSITE ABOVE LEFT Jenny Burns (student). *Pastel.* A2 drawing of part of the Eiffel Tower, drawn on the spot.
OPPOSITE ABOVE RIGHT Jenny Burns. *Pastel.* A1 interpretation.
OPPOSITE BELOW Notebook ideas for the theme of movement.

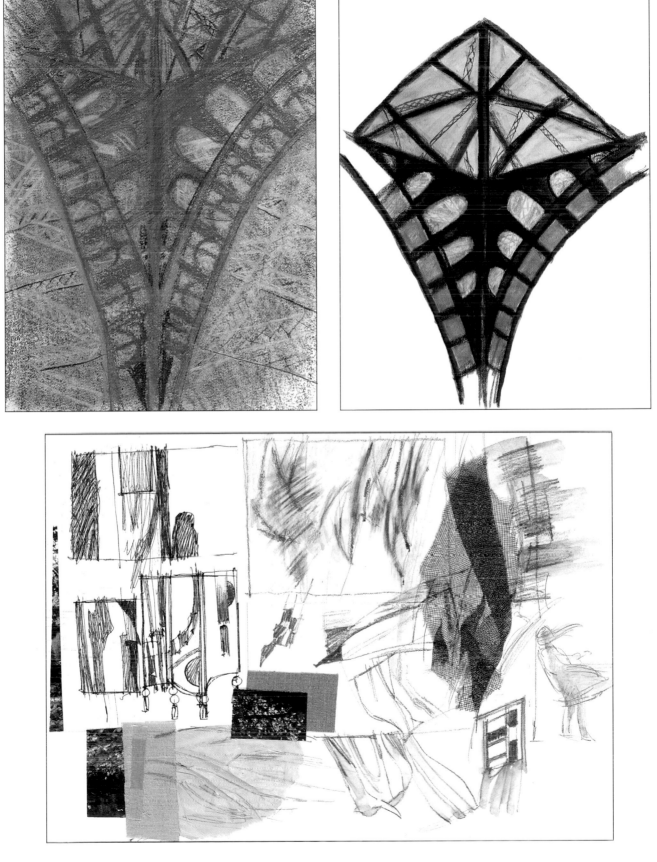

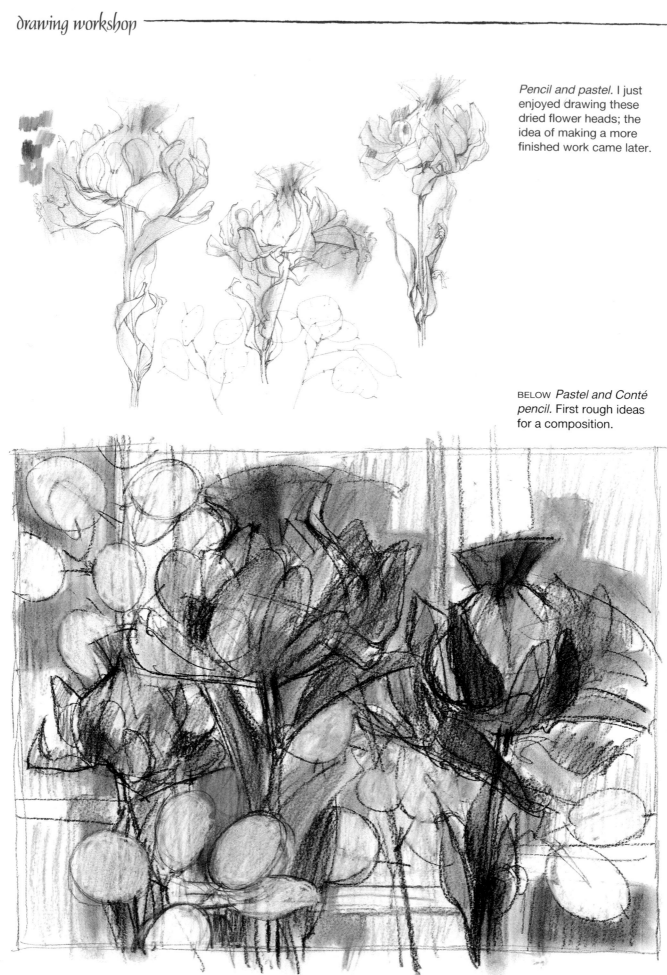

Pencil and pastel. I just enjoyed drawing these dried flower heads; the idea of making a more finished work came later.

BELOW *Pastel and Conté pencil.* First rough ideas for a composition.

You may, though, have a number of small drawings or scraps of information. As long as there is enough, it may be that you can put all the parts together in some way. I drew these dried flower heads to keep my hand in, became interested, and then tried to put them into a composition. The end stage so far is not a satisfactory piece of work – I'd want to clarify in my mind just what I want to say about the subject before going on. A work is never finished until there is nothing more to be done to improve it.

Pastel and pastel pencils.
This drawing could be developed at some time in the future.

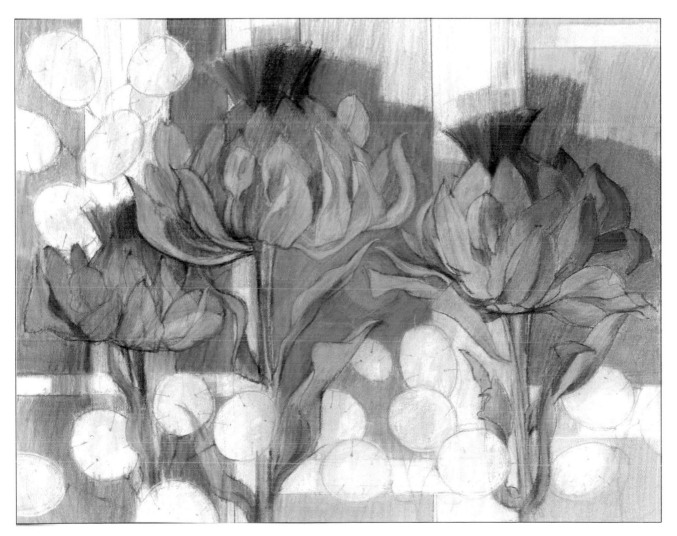

CHOOSING AN APPROACH

If you are still puzzled about having 'something to say', ask yourself questions about your subject. For example, if you have decided to draw a building site, are you interested in the big shapes, the turmoil and noise, or the ladders, cranes and other paraphernalia? Is the scale right? Do you feel the subject is strong? Take an idea like 'strength' and think how you can add this feeling to the drawing. We talked a little about this with natural forms, but here we have greater freedom – to choose freely from our tools and media and to cut out anything which detracts from our aims. So think about this very carefully before you start, and suit the tool and medium to your aim as well as to the subject.

If you have been working big and broadly, then go to the other extreme and do a very small, fine drawing, regardless of the subject. This may seem traumatic but it will jolt you into fresh thinking. It works even better the other way, as most people tend to think that small is safe. So think big. If you have the space to work and want to invest in another piece or two of plywood, try a big drawing – A2 or even A1. You'll need chalks or thick, soft pencils to make big scale marks – and don't fiddle! Give yourself enough time and pick something which can be left and returned to another time, like the view from a window.

When you have tried these extremes, go for something mid-way and perhaps use tools you've neglected. Try not to think, 'But I don't like this way.' Ruts and routine are ageing, both to people and to work. Thinking openly and experimentally keeps everything young and fresh, but watch your standards. It's not enough to get ideas – you must aim to make a visual statement about them work effectively and be understood by others.

I wonder if some of you have found your work overlapping into the area of painting? The line between painting and drawing is often imperceptible and this is a good way to move from one field to another; the underlying drawing to your painting will be more sound than if you were to try to paint without the earlier study.

Good drawings are no less 'frameable' than paintings, but nothing should be framed until it is of top standard. Keep all your drawings; eventually you will notice an amazing improvement.

Now re-read this book from the beginning and do a thorough check on how, why and when you use each tool or medium. Pretend you are beginning again and, in the light of your present knowledge, analyse your experiments and ideas and make more drawings of different subjects. You will find you have greater confidence this time round.

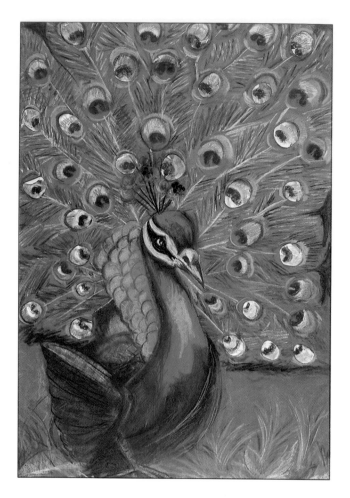

Sarah Wasserberg (student). *Pastel and gold paper.*

tip

If you don't want to put your current piece of work away for a whole week in order to see it with fresh eyes, look at it in a mirror instead, or turn it upside down and stand a good distance away – at least six feet. These devices often show up both weaknesses and strengths. Take a long look rather than a quick glance – even drink a cup of coffee while you look.

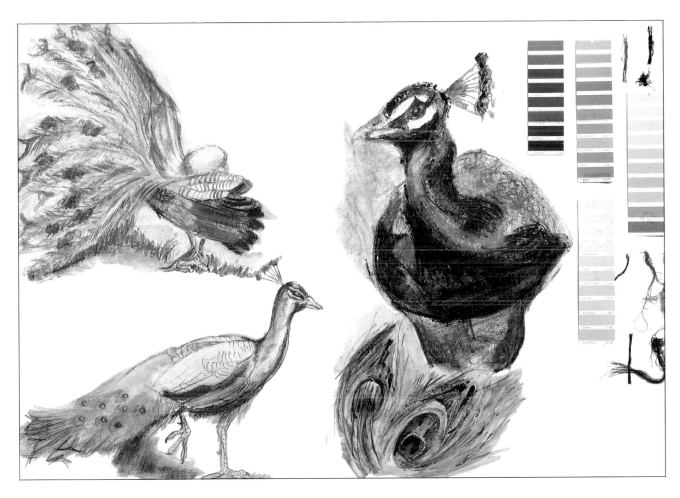

ABOVE Sarah Wasserberg (student). Sheet of preliminary studies.
LEFT *Pastel and pastel pencil*. The shapes in the bark seemed more interesting than the whole tree.

project

Take any (or all) of these themes and extend your work as far as you can and in as many media and tools as are suitable:

Balloons	**Pendant**
Horizontals	**Lines in an urban setting**
Kites	**Flowing**
Eye/Potato/Needles	**Gates/Fences**
Two peas in a pod	

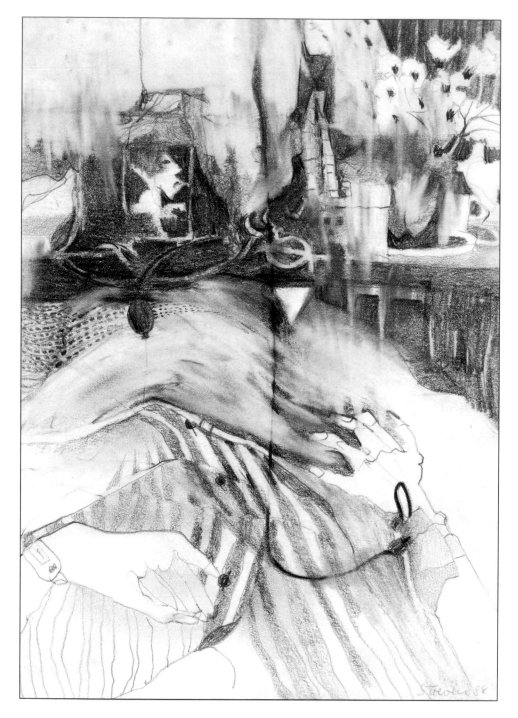

Shirley Trevena, 'From a Hospital Bed'. *Pencil.*

We are coming to the end of the book, so let's make the last project a good one! Pull out all the stops and use your newly found investigative powers and ability to draw just how and what you want. Try to develop a balanced sense of self-criticism – don't expect too much too soon, and don't get depressed. Keep aiming at a standard just beyond your reach.

For the future just draw, anything and everything, without fretting about success or failure. The process of doing and progressing is the real success story. This drawing by Shirley Trevena was made while she was in hospital, the last place most people think of drawing, but if you are capable, this is what it's all about. Think how lucky you are to have such a strong desire to do something that you are willing to get down to studying and enjoying it in depth. Many people never have that good fortune, and even if they do, some don't have the certainty and passion actually to set about doing it.

Drawing is about learning to see our world with new eyes. It is also fun and is marvellous, so go to it and love every minute of it!

acknowledgements

The author and publishers acknowledge the help and co-operation of the following:

Work by the late Charles Keeping reproduced by kind permission of Mrs Renate Keeping, OUP, and Blackie & Sons Ltd:
Adam and Paradise Island (OUP)
Charles Keeping's Book of Classic Ghost Stories (Blackie & Sons Ltd)
The Highwayman (OUP)
The Lady of Shalott (OUP)
Beowulf (OUP)

Work by Alan Hume reproduced by kind permission of:
Mr & Mrs J. Dorsett – 'Harmony'
Mr & Mrs K. Milton – 'Mechanical Profile'
Mr & Mrs R. Barnes – 'Patterns on the Road'
Mr & Mrs R. E. Budd – 'Me Dad's Handcart'

Illustrations by Doreen Roberts reproduced from *The Fight for Arkenvald* by Thomas Johnston, published by Collins Publishers Limited.

Photographs on pages 8, 9, 11, 12, 13, 23, 55 and 57 by Ed Barber, all other photographs by the author.

Work by students reproduced by kind permission of Middlesex Polytechnic.

The following additional artists for permission to use their work:

Clifford Bayley	Ian Simpson
John Blockley	Stan Smith
Tom Coates	Raymond Spurrier
Alan Hume	Shirley Trevena
Moira Huntly	Jean Vaudeau
Ian Ribbons	

All drawings not otherwise specified are by the author.